A LOVE AFFAIR WITH

NATURE

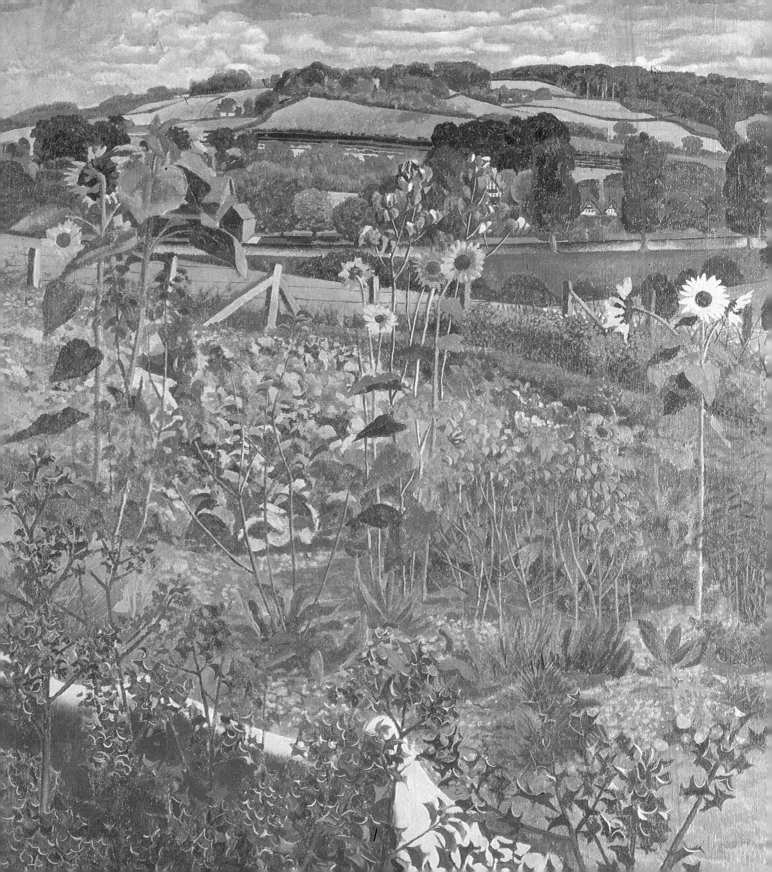

A LOVE AFFAIR WITH

NATURE

Edwin Mullins

PHAIDON·OXFORD | A CHANNEL FOUR BOOK

I should like to express my gratitude to many who have helped bring this 'love affair' to fruition. Television South (TVS) gave sturdy support to the book, as well as to the films which accompanied it, and in doing so gave me the opportunity to explore my own country more widely than—to my shame—I had ever done before. Among the staff of TVS to whom I am particularly indebted are John Miller, Richard Argent, Jean Orba, John Mills, Monica Murphy and Michael Pilsworth. My agents at Curtis Brown, Felicity Bryan and Sue Freathy, supported me through a few difficult moments. Phaidon Press welcomed the book with an enthusiasm I have come to associate with them. My beloved wife Anne provided a priceless intellectual stimulus without which many of the ideas might have lost their way. Finally, all those who allowed me to tramp across their land, peer at their art treasures, and to reproduce the photographs in this book, deserve at the very least my profound thanks.

E.M.

Phaidon Press Limited, Littlegate House, St Ebbe's Street, Oxford OX1 1SQ

First published 1985
Text © Edwin Mullins
© Phaidon Press Limited 1985

British Library Cataloguing in Publication Data

Mullins, Edwin
 A love affair with nature: a personal view of British art.
 1. Art, British 2. Nature (Aesthetics)
 I. Title
 709'.41 N5303

 ISBN 0-7148-2404-6

Printed in England by Jolly & Barber Ltd, Rugby, Warwickshire.

Calligraphy based on a design by David John Graham

FRONTISPIECE: Stanley Spencer, *Rowborough, Cookham*. Oil. 1934. Private Collection.

CONTENTS

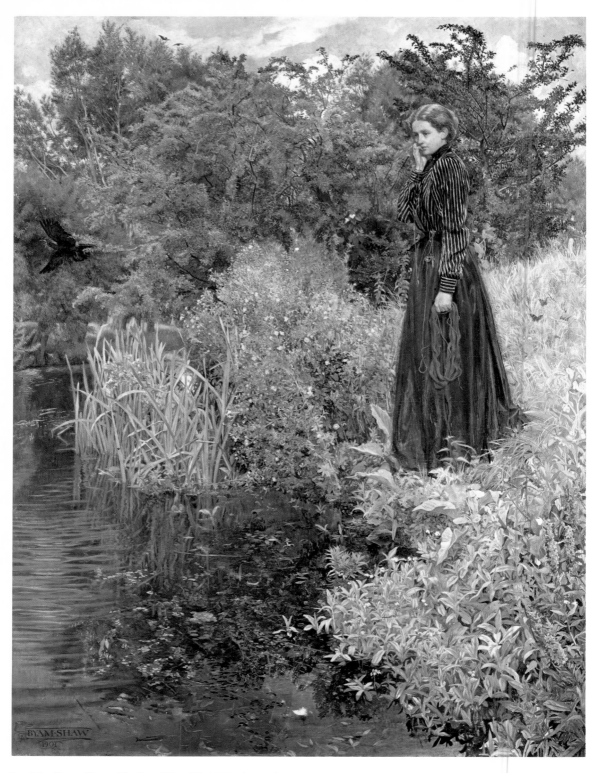

1 John Byam Shaw, *The Boer War*. Oil. 1901. Birmingham, City Art Gallery.

INTRODUCTION

he British love of nature is proverbial. We are a nation of gardeners, walkers, bird-watchers, plant hunters. We listen for the first cuckoo, lament the last swallow. This book examines how this love of nature has engraved itself upon our life, our art and our environment. The central thread of the book is the relationship between British painters and nature, chiefly because it is paintings which offer the clearest body of evidence we have of how ideas about nature have been visualized, and how these have changed over the passage of time. But I have also tried to show how such ideas have been reflected in architecture, in the applied and decorative arts, in poetry and prose, in advertising, in industry, and in the use of the landscape itself.

This British 'love affair' has been a stormy one. A love of nature has not in-frequently been in conflict with other affections: science, progress, trade, wealth. It can be no accident that the nation now most fervent in the field of conservation should be the very nation which created the Industrial Revolution. In Oscar Wilde's words, 'each man kills the thing he loves.' Out of this conflict of loyalties has emerged a profound British nostalgia for a pre-industrial Arcadia.

By limiting this book to the British Isles I am not suggesting that other countries have never concerned themselves with the natural world. They have, of course, and do. But if I am to single out one nation whose culture has demonstrated a love of nature most consistently, then Britain has to be my choice. To look at the British relationship with nature—what it has been and how it has shifted—is to see in sharper focus than elsewhere how the civilizations of the west have behaved towards an environment they have at different times feared, worshipped, needed, exploited and subordinated to their desires.

As for the word 'nature', I have interpreted this to mean what I believe most people understand it to mean—namely, 'the world about us'. Even this requires some qualification since cities, roads, railways and power stations are all part of the world about us without being part of nature, though trees which line a city street and sparrows that nest under the eaves *are* nature. Oil under the North Sea is part of nature: drilled, refined and piped into a jumbo jet, it is not. So, lines of definition blur. Never mind: I hope the general interpretation of the word will not pose problems.

This is a book built upon ideas first formulated as scripts for the television series 'A Love Affair with Nature', written for Television South (TVS) and first transmitted on Channel Four in the autumn of 1985.

NATURE AND
LANDSCAPES

Feeling homesick in Italy, the Victorian poet Robert Browning voiced his love of England as a love of nature. Had he written about the lovers and friends he missed, or about favourite buildings or books, or institutions, or food, Browning might have written one of the less memorable poems in the English language, instead of one that everyone remembers and responds to as if the sentiments were truly our own. By describing homesickness in terms of nothing more than an everyday garden bird chirping on a tree in springtime Browning plucks a national, if not necessarily a universal, chord.

> O to be in England
> Now that April's there,
> And whoever wakes in England
> Sees, some morning, unaware,
> That the lowest boughs and the brushwood sheaf
> Round the elm-tree bole are in tiny leaf,
> While the chaffinch sings on the orchard bough
> In England—now!

This is a simple phenomenon which intrigues me—the way we hook human sentiments on to particular objects. It is as if passions can only find an identity by fixing themselves on to some potent image stored away in the brain, and without that appropriate image those passions can never be fully understood. They remain disembodied. Ghosts. And one of the most powerful means of bringing them to life is by relating them to what we see in the natural world. No greater mark of value can be placed on any human experience than to see what it *looks* like in nature; so the natural world becomes a mass of visual metaphors—a gigantic reference library for our feelings. Courage looks like a lion, strength like an oak-tree, homesickness like a little bird.

To look at England is to look at a land that has been well loved. And to look at English landscape painting is to see why it has been well loved.

Landscape painting is among England's most brilliant creative achievements. What it expresses is a bond between man and nature that is so deeply felt, so passionate, it is like a religious faith. In fact it seems to me that landscape painting may be the closest thing to a religious art that England has produced since the Middle Ages—or, to be more precise, since the killjoys of the new Protestant Church decreed that church painting was no better than idolatry and that houses of God should be clean and bare.

It is an important moment in the history of human perception when a stretch of countryside becomes a 'landscape'. It marks a radical change in the way people in general feel about their natural environment. To see a stretch of countryside as a 'landscape' implies that it is interesting, valuable, even loved, that it has a perfection about it and therefore has some truth to tell. A 'landscape' relates to mankind as a stretch of countryside does not.

This idea that the natural environment is a valid subject to paint—just by itself and not as a backcloth to stirring human events—is not a very old one. The little watercolour

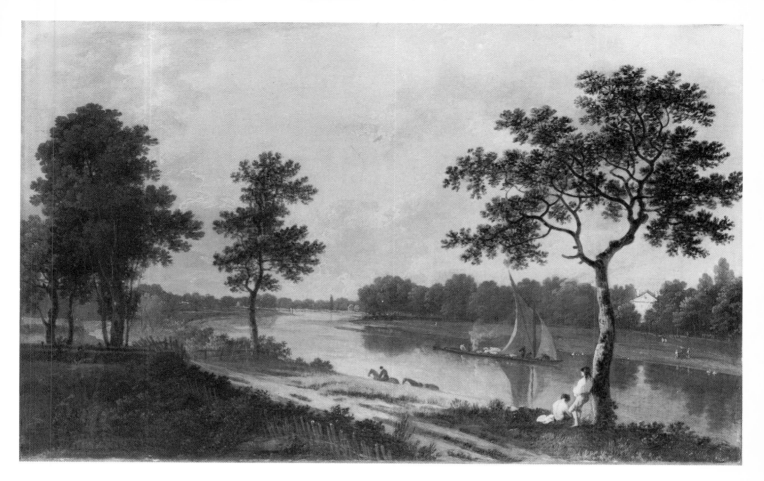

sketches which the German painter Dürer made crossing the Alps on his way to Venice at the beginning of the sixteenth century are among the first expressions of this novel idea.

A few years later Dürer's fellow-countryman, Altdorfer, extended the fascination for landscape into full-scale oil paintings. There are figures, and there are events, but these are often quite secondary. They merely animate the mood of nature.

In the seventeenth century the Dutch—like the English deprived by Protestantism of the traditional practice of church art—found in landscape the most natural subject of contemplation and enjoyment. There have never been more landscape painters than in seventeenth-century Holland, and never more people to buy their work. The Dutch brought landscape into their houses with a welcome that other nations were to take more than another hundred years to achieve.

In England, until well into the eighteenth century, paintings of landscape are little more than demonstrations of a man's pride in his possessions. They are portraits of property—generally from a bird's-eye view to ensure that the artist gets it all in. They are animated maps to hang on stately walls offering reassurance that God is in his heaven and all is well with the world. The owner's grand house sits in the centre, and his garden and his lands are spread around it—orderly, perfectly controlled, and tilled and pruned by tidy peasants. They are like pictures of human beehives.

Then, from about the second quarter of the eighteenth century, English artists begin to record quite a new spirit that was blowing across the English countryside. Landscape as

Richard Wilson, *The Thames near Twickenham*. Oil. (?)1762. Twickenham, Marble Hill House.

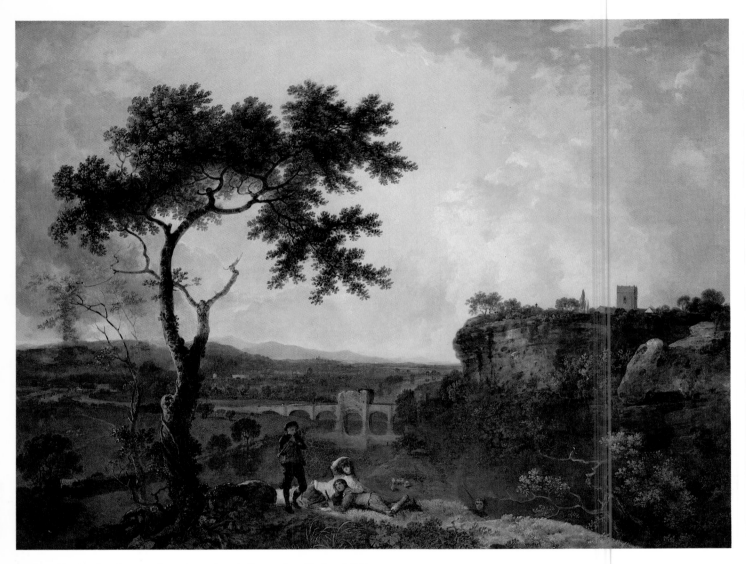

2 Richard Wilson, *Holt Bridge*. Oil. 1761/2. London, National Gallery.

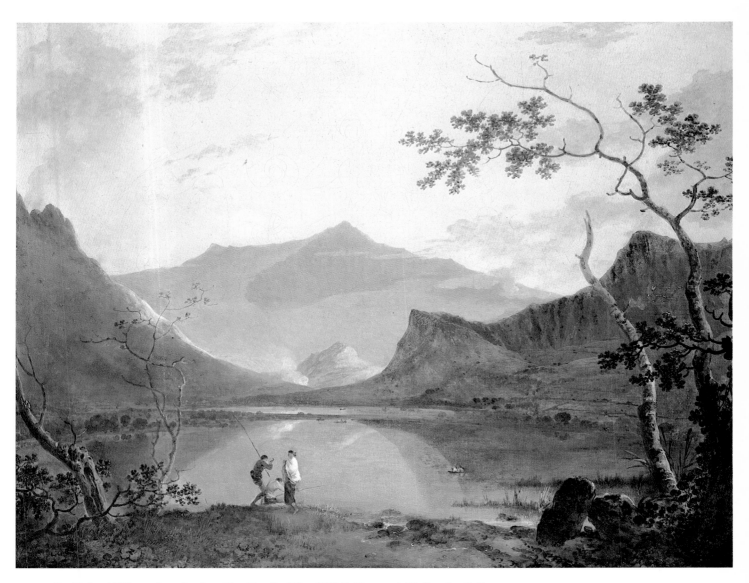

3 Richard Wilson, *Snowdon from Llyn Nantlle*. Oil. *c*.1765/6. Liverpool, Walker Art Gallery.

property becomes landscape as a focus of private sentiments. This is the crucial moment. The artist becomes the interpreter of what people feel about the countryside around them—how they relate to it, what values they perceive in it, what they enjoy about it. It is no longer necessary to own the land to find the landscape rewarding and spiritually uplifting.

At the heart of this new mood is a growing cult of the imagination at the expense of the deeply cherished eighteenth-century belief in reason. One of its prophets was the Scottish philosopher David Hume. He exalted the human imagination as a key to understanding the world we live in, as against abstract reasoning which, he said, led only to incoherence.

This notion that in order to understand the world you have to open your eyes and your senses was taken up by a number of mid-eighteenth-century poets. We find James Thomson extolling Britain as 'the world of waters wild', and thrilling to the way 'The Atlantic surge / Pours in among the stormy Hebrides.' And William Collins longing to be guided to some lonely hut 'That from the mountain's side / Views wilds and swelling floods, / And hamlets brown, and dim-discover'd spires. . . .'

Suddenly nature is to be grasped, held in awe, viewed as a wonderful spectacle

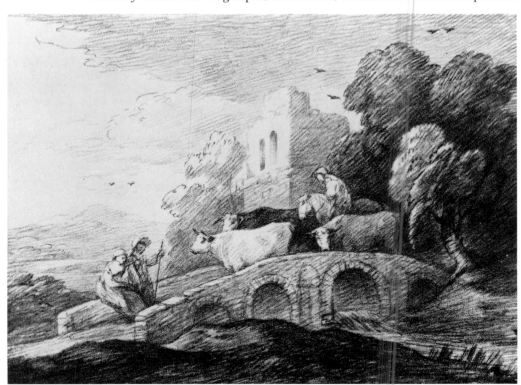

Thomas Gainsborough,
*Landscape with
Herdsmen Driving
Cattle over a Bridge.*
Soft ground etching.
1779–80. London,
British Museum.

and as a mirror of all manner of passions. She is all alive, and artists feel themselves to be more alive in her company. It is from this moment that English landscape painting begins to tell us what artists have found to love about the countryside of England.

It begins with a dream—a daydream of what England could be made to look like if a magic wand were to transform the English climate into that of Italy. I should really say 'British', and not 'English', because the artist responsible for this dream of an Italianate landscape was a Welshman, and many of his loveliest landscapes are of the mountain scenery of Wales. He was Richard Wilson. The great Victorian critic John Ruskin wrote, 'I believe that with the name of Richard Wilson the history of sincere landscape art founded on a meditative love of nature begins in England.'

Wilson was born in 1713 or 1714, the son of a Welsh clergyman. The experience that seems to have had the profoundest influence on how he came to look at his native countryside was the sound classical education which his father gave him. His mind would have been soaked in the Latin poets—Virgil, Horace, Ovid—and therefore in the idyll of the perfect classical landscape of the Roman Campagna.

It is generally claimed that Wilson's years in Italy during the 1750s fired his imagination to paint as he did, and that on returning home in 1757 he proceeded to transplant that Italianate vision of nature on to the native landscape. But Wilson was already middle-aged when he first set foot in Italy. And although his principal occupation before his departure was portraiture, he did paint a number of landscapes in these earlier years and they possess just the same tranquil, idyllic atmosphere as those done after his return.

There are two almost identical views of Caernarvon Castle, for example, painted twenty-one years apart. Both of them are blissfully pastoral, in the mood of a bucolic siesta, and I doubt if anyone not knowing the dates would be confident which of the two was done before Wilson had ever crossed the Channel. No, it was his reading of the Classics, and perhaps exposure to copies of the works of Claude and Gaspar Poussin, that tinted his vision with an Italian light. Travelling to Italy confirmed what was already in Wilson's head.

What Wilson loved about the landscape was its grandeur. It was not the kind of grandeur to appeal to the Romantics half a century later: nothing in a Wilson landscape ever sets the spirits racing. No danger. No awe. No magnificent discomfort. Just this overwhelming serenity. In his view of the River Thames near Twickenham—hardly a theme of heroic potential—the river sweeps on and on into the distant plain of London like a long curving mirror of the vast sky. And sentinel oak-trees mark its course.

Everything in his landscapes is perfectly, handsomely, in its place. Invariably this pastoral idyll has a very slight human touch—figures who inhabit the scene in precisely the spirit of the landscape itself, as if drugged by it. Sometimes they are gentry out for well-dressed strolls. More often they are labourers, but even they go about their tasks in a lackadaisical way so as not to disturb the prevailing mood. They are rather small in scale, and they do peaceful things like sailing boats, watering animals, fishing; or else they just admire the view as though directing us to do the same (Plate 2).

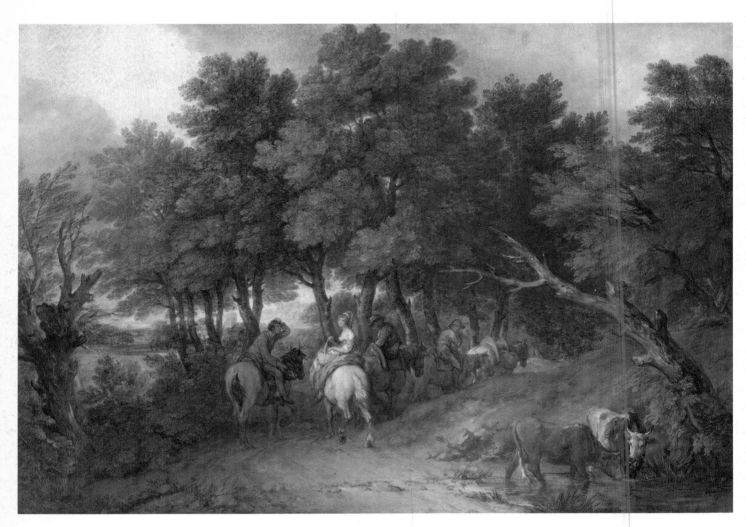

4 Thomas Gainsborough, *The Road from Market*. Oil. 1767/8. Ohio, The Toledo Museum of Art.

OPPOSITE 5 Thomas Gainsborough, *Wooded Landscape with Figures, Animals and Distant Village* ('*Gainsborough's Forest*'): detail. Oil. 1748. London, National Gallery.

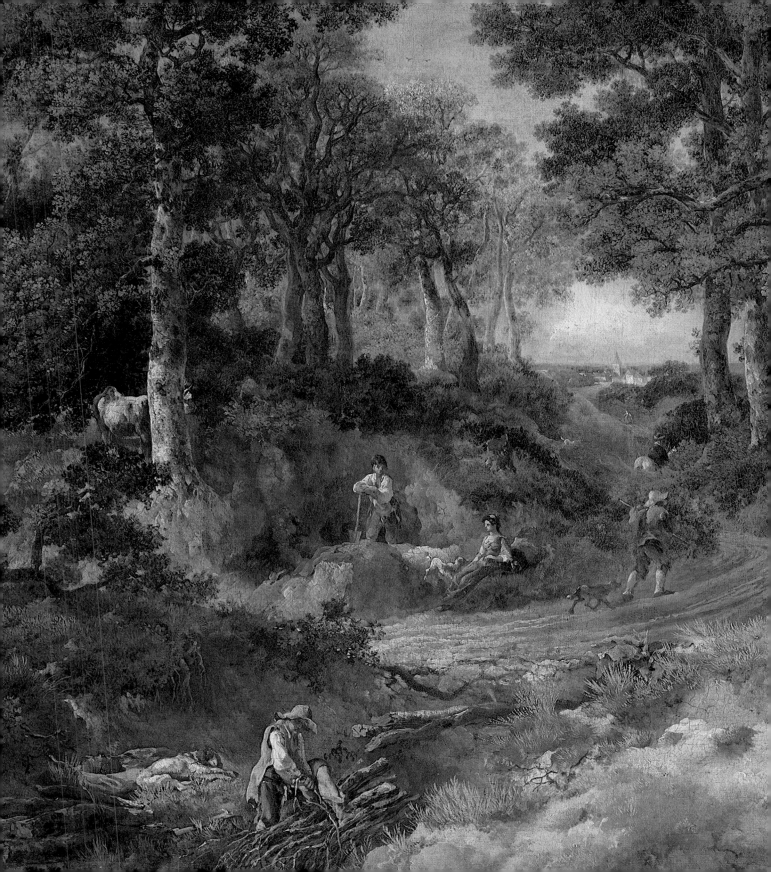

John Constable, *The Stour Valley and Dedham Church*. Oil. 1814–15. Courtesy Museum of Fine Arts, Boston: Purchased William W. Warren Fund.

Of course Wilson cheated—quite deliberately. Natural wildness had to conform to rules. His response to nature was an urge to improve it. Even the two most rugged peaks in Wales, Snowdon (Plate 3) and Cader Idris, are embalmed in this fashion. No one who has ever climbed Snowdon is likely to have found it quite so lofty, or viewed it in a purple heat-haze reflected in the limpid waters of Llyn Nantlle. As for Cader Idris, it is certainly not like this. In Wilson's painting the central crag has been smoothed and drawn upwards, the surroundings flattened out for contrasting effect, while the foreground as far as I can see is entirely imaginary.

The beauty of Wilson's art is the manner in which it reflects that daydream of a pure and untarnished land where man is in harmony with nature, and nature with whatever supreme forces guide the affairs of this world. The fact that it is Britain over which he waves his wand, and not the classical lands, renders this vision even more moving because we know it is his eye that is performing the magic. This was how in his mind's eye he actually saw Britain.

The second major figure in eighteenth-century English landscape painting is Thomas Gainsborough. Fifteen years or so younger than Wilson, Gainsborough was the son of a country clothier in Suffolk, who certainly gave his fifth and youngest male child none of the sound classical education that Wilson received.

Gainsborough was never a learned man. His vision of landscape never acquired that well-educated gloss polished by nostalgia for the Grand Tour; and this absence of classical bookishness is part of Gainsborough's sincerity and charm. His vision of nature is that of a countryman who loved the East Anglian landscape of his youth and responded to it with an earthy warmth.

But it is not only that. Gainsborough was a countryman who, as soon as he could, became a townsman, and the most brilliant society portrait painter England ever produced. He went to Ipswich, then up the social scale to fashionable Bath, and finally at the height of his success to London, where he had a studio in Pall Mall.

So, to Gainsborough the countryside was also the place of peace that he left further and further behind. Except for about four years as a young man when he practised in his native country-town of Sudbury, Gainsborough painted all his landscapes from the viewpoint of a city-dweller. He saw the countryside as a place of romantic escape, where a man could be alone with his sentiments. 'I'm sick of portraits and wish very much to take my Viol da Gamba and walk off to some sweet village where I can paint landskips and enjoy the tag end of life in quietness and ease.'

Gainsborough's view of the countryside increasingly comes to be that of a man distancing himself from the reality of it. Nature is a dream that grows ever sweeter—a rustic playground in which people do nothing rather graciously, and animals wander about in the sun looking contented. A place where pretty milkmaids ride through forests on a summer morning, and nymphs borrowed from Greek myth splash about in waterfalls (Plates 4 and 5).

In the early landscapes this vision has a more solid look. The style of the young Gainsborough was deeply influenced by Dutch painting, with its feeling for weather and light and blustery skies. Where Wilson saw England as Italy, the young Gainsborough saw it as Holland.

What is un-Dutch about these landscapes is the sentiment which pervades them. The more closely you look at Gainsborough's little human figures the less they seem to belong to these rough and rugged places. They recline elegantly among wild flowers; they chat, they flirt, they while away the summer days. The animals they are supposed to be tending clearly do not need their attentions, and they too seem to mooch around without much direction or purpose. This is really a landscape designed for small pleasures, not work—the setting for talk, for relaxation and for love. And the artist who introduced Gainsborough to nature in this mood was not Dutch, but French: Antoine Watteau.

It is the French mood of his landscapes that gains ascendancy over the Dutch as Gainsborough climbs the ladder of fame and wealth. As he begins to gild the English aristocracy with glamour, he begins to gild nature too. The feathery woodland settings where his duchesses rustle in their gorgeous silks and satins remain just as feathery even when there are no duchesses present. Nature becomes an artificial Arcadia in which the poor are shown to be just as contented as the rich. They sit smiling and pretty outside cottage doors in their clean rags, or they follow their herds homeward through delicious sunsets.

It grows easier and easier to see what Gainsborough loved about the English countryside. He loved it as a dream of happiness. Like Richard Wilson he closed his eyes and saw a pure and untarnished land where man was in harmony with nature. And, as an artist whose painterly skills were greatly superior to Wilson's, he employed that remarkable lightness of touch to perform a conjuring-trick so deft and so appealing that we long to believe it is true.

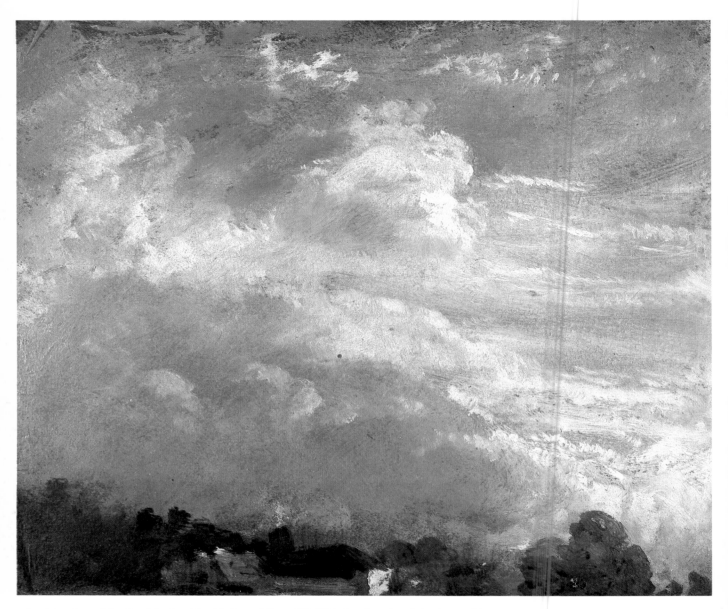

6 John Constable, *Cloud Study with a Horizon of Trees*. Oil. 1821. London, Royal Academy of Arts.

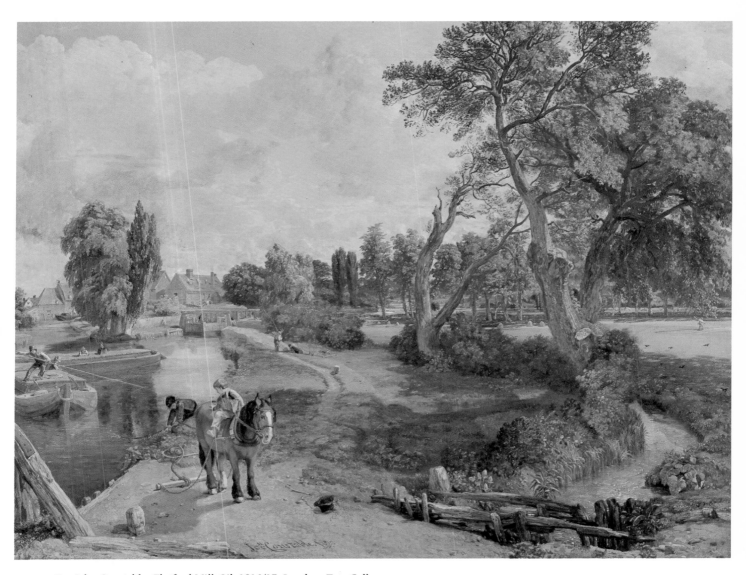

7 John Constable, *Flatford Mill*. Oil. 1816/17. London, Tate Gallery.

Just nine miles across the rivers and flat fields from Gainsborough's birthplace, Sudbury, is the village of East Bergholt where Constable was born. They shared the same landscape of their youth.

Perhaps the most significant difference between John Constable and Thomas Gainsborough is not that Constable was almost half a century younger, but that he was a countryman who remained a countryman at heart all his life. Constable loved nature for itself. It is not a place of romantic escape. It is the natural environment of man, where he most rightly belongs and is most himself; where he lives and toils. Nature is his home and his workshop. 'We exist but in a landscape', he wrote, 'and we are the creatures of a landscape.'

Constable's response was always strongest to landscape which he knew like a friend. If he is England's favourite painter, as he surely must be, then I feel certain it is because he has conveyed better than anyone else that warm intimacy with a known patch of land which the English feel so deeply, and which finds its widest expression in the national hobby of gardening.

In our hearts I suspect we would all like England to look exactly as it looks in a Constable landscape, and to be able to express our sentiments about it as deeply and as eloquently as he did. The quality of feeling in a Constable landscape is unmistakably connected with an intense love of place. The vigour and excitement of those brushstrokes—in the oil-sketches above all—convey joy like the notes of a song.

The sturdy horse towing a barge in the famous canvas of Flatford Mill (Plate 7) is not just a scene Constable witnessed one day while he was out sketching. Constable's father had owned Flatford Mill, and these barges would carry corn under the little footbridge just out of sight in the painting but which the bargee is about to negotiate with his long pole. The barges would then pass further along the River Stour to a wharf where they would discharge their cargo, pick up a load of coal and make a return journey past the mill and through Flatford Lock towards Manningtree, the old horse plodding back along the tow-path. And across the water-meadows between the trees to the south rose the church-tower of the neighbouring village of Dedham, to which the artist had walked daily to school as a boy.

In a short journey I have described the setting of hundreds of Constable's drawings, sketches and oil paintings. At heart he was a painter of the familiar scene. He was precisely the opposite of Turner, the restless traveller. Constable did indeed travel, and yet for the essence of his entire life's work he could have remained within an easy day's journey of his native village of East Bergholt.

A mark of this affection for the familiar is Constable's attention to detail, what to other artists would have seemed quite irrelevant detail. 'Old rotten banks, slimy posts, and brickwork. I love such things,' he wrote. Constable maintained that his art was 'to be found under every hedge, and in every lane'.

He might have added 'and in every sky'. Nothing in Constable's work is so typical of the man as his love of painting clouds. The most fleeting of things, clouds seemed to add even more verve to his brush as he sought to get down on canvas those tumbling shapes and flickering

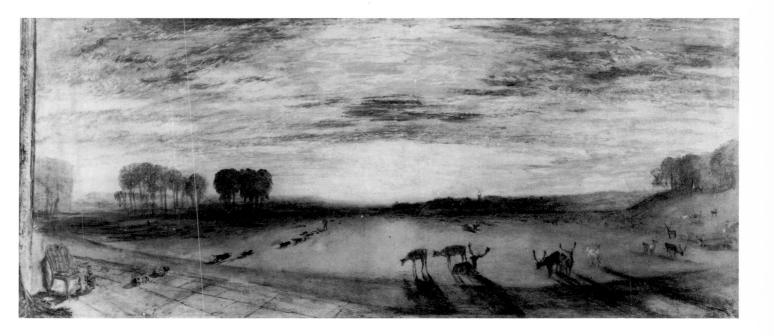

colours that were altering and vanishing as he caught them (Plate 6). Here was an urge to give permanence to the most momentary effects in nature, which none the less seemed to be the very essence of nature: the climate, rain, sun, wind, thunder.

So far it has been relatively easy to answer the question 'What have artists loved about the countryside of England?' With Wilson, Gainsborough and Constable their affections are clearly and consistently stated in their work. It is not so with Turner, Constable's great contemporary, because broadly speaking his response to landscape, and to nature generally, is of two seemingly opposite kinds—he loved both the majestic tranquillity of nature, and its magnificent and fearful drama. The two preoccupations run concurrently throughout his life's work.

Turner in love with tranquillity responds to intimate, friendly, rather ordinary scenes like the River Thames near Walton Bridge, or the Brighton Chain Pier with sailing boats. The atmosphere is sometimes rather luminous and Dutch, and sometimes closer to Constable's affection for scumbled textures and little points of light. Or else it evokes the idyllic vision of the French seventeenth-century landscape painter Claude Lorraine—with an expanse of limpid scenery flattening out and growing cooler and cooler as it approaches an enormous horizon.

Or, again, his paintings can be a paean to light and colour—the Petworth and Chichester Channel paintings in particular, where the canvases are stretched like a panoramic

J.M.W. Turner,
Petworth Park:
Tillington Church in the
Distance. Oil. *c.*1828.
London, Tate Gallery.

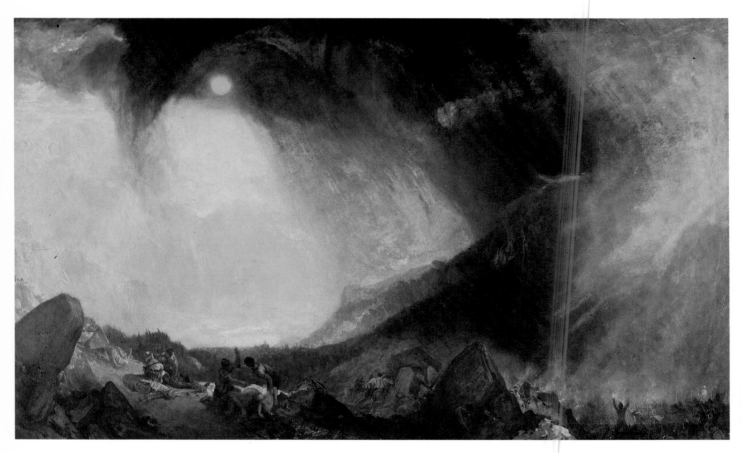

8 J. M. W. Turner, *Hannibal Crossing the Alps*. Oil. Exhibited 1812. London, Tate Gallery.

OPPOSITE **9** Samuel Palmer, *A Hilly Scene*. Tempera, watercolour and pen. *c*.1826–8. London, Tate Gallery.

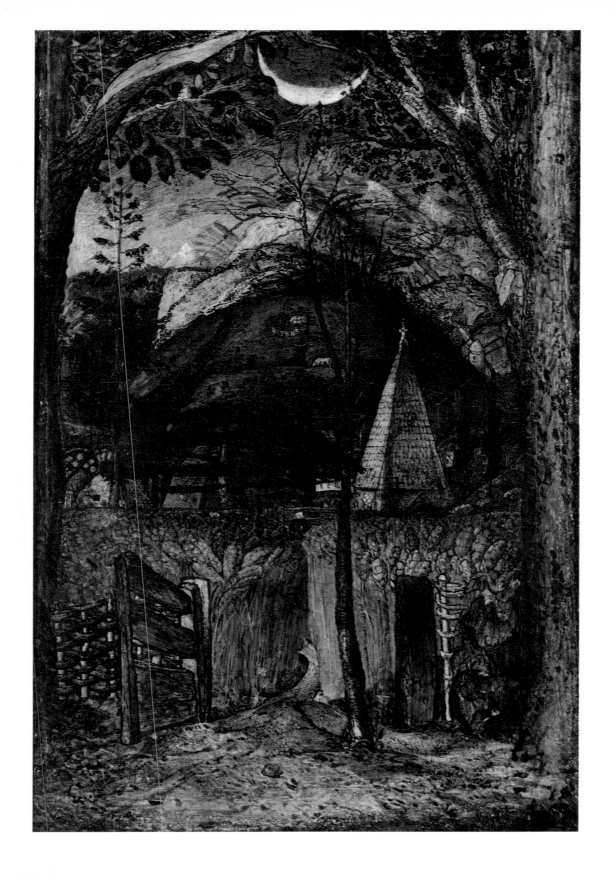

screen to embrace the full breadth of deer-park or water embalmed in a golden light, and the eye is steered as if down a long bright tunnel towards the setting sun. From here it is not so great a leap after all to those dramas of nature—the storms at sea, the snowstorms, the avalanches, the fires by night—in which natural forces supply primitive energy to reshape or destroy the world.

There is one characteristic of Turner's vision which stands out particularly clearly in these great melodramas of nature. And it is one that separates him from all the other artists included in this chapter. It is that Turner seems emotionally detached. Perhaps this is why people often find it easier to admire him than to love him.

His feelings, unlike Constable's, are not really directed on to a place or a specific scene. It is the phenomena of nature that engage him—its poetic or theatrical content. *Slavers Throwing Overboard the Dead and Dying* is one of Turner's most impressive visions of natural forces at work. Yet the subject is actually horrific: bleeding bodies toss among the stormy waves; legs, arms, hands here and there are being devoured by what resemble outsize piranha fish, and some sort of leviathan is on its way to clean up the remains.

And Turner absolutely does not care. There is none of the agonized pathos of, for example, Géricault's *Raft of the Medusa*, or Delacroix's *Barque of Dante*, both painted in France at much the same time. In Turner's canvas the bodies are so much flotsam. What he cares about is this grand symphony of light, fire, wind and water.

Turner thrilled to the experience of nature as a threat. He loved the epic quality in nature, and he saw this as the natural accompaniment to, and expression of, the epic quality in life—which he also loved. It is impossible to imagine any other English painter having himself lashed to a mast for four hours during a storm at sea at the age of sixty-seven. 'I did not expect to escape,' he wrote, 'but I felt bound to record it if I did.'

There is one conversation, reported by a friend to Turner's first biographer, which gives the clearest insight into the alchemy of the artist's imagination—his ability to record nature absolutely faithfully, then detach himself from the particular moment and transform the scene into the setting for epic action.

In 1810 Turner was staying with a friend called Walter Fawkes near the Wharfe valley in Yorkshire. There was a tremendous storm and Turner called out to Fawkes's son Hawkesworth: '"Hawkey!—Hawkey!—come here—come here! Look at this thunderstorm! Isn't it grand?—isn't it wonderful?—isn't it sublime?" All this time he was making notes of its form and colour on the back of a letter. . . . Presently the storm passed, and he finished. "There," said he, "Hawkey: in two years you will see this again, and call it Hannibal Crossing the Alps."' Two years later the picture, now in the Tate Gallery, was exhibited at the Royal Academy under that very title (Plate 8).

This ability to let nature work upon the imagination until it acquires quite a new meaning is also a characteristic of the youngest of the five landscape painters discussed in this chapter: Samuel Palmer.

Nearly a century separates Palmer from Wilson; more than a quarter of a century separates him from Turner. He was an artist who grew up in the flood of early nineteeenth-

century Romanticism. The first overwhelming impetus he received as a young painter was his meeting with the elderly William Blake in 1824, when Palmer was nineteen. He wrote that the encounter was 'a kind of vision'.

Palmer lived to a ripe old age to become a somewhat saccharined Victorian view-painter; yet the work for which we chiefly value him today is the product—few in number and small in size—of just a few youthful years spent in the Kent village of Shoreham. Here he painted tiny intense landscapes that evoke a pastoral paradise (Plate 9).

Palmer is the only artist among these five for whom a love of nature is the expression of a love of God. He painted the landscape around him through the eyes of a Christian mystic. Man alone with nature is alone with God's works, and the experience of nature is the experience of a divine hand.

In fact, it is hard to separate Palmer's nature worship from his Christian worship; the two seem inextricably entwined. The Shoreham paintings mirror a wonderfully passionate response to nature. They are like small votive offerings. Everything that grows and flowers becomes an image of divine fecundity and an echo of paradise. Man and God's creatures are small under the embracing hills. Shepherds watch their flocks while church bells toll in the twilight. Branches of trees meet overhead to form a Gothic window—nature's church. The tracery of leaves touches the spire of man's church like a blessing, uniting man with nature and man with God.

What conveys this vision so eloquently is not just Palmer's dramatic practice of laying highlights in thick white blobs against backgrounds of Stygian blackness. It is also the emphasis he places on each individual image within the picture. With heavy strokes and splodges of Indian ink he outlines his trees, hills, clouds, birds, human figures, until each painting takes on the appearance of highly polished marquetry, each image set firmly like a solid object into the composition.

It is this tactile quality—as if each image were a separate piece of a jigsaw—which gives these Shoreham paintings their unreal, almost primitive, appearance. They look like dreams, landscapes of the mind, set down image by image in such a way as to convey the tremendous significance they held in the artist's vision of them.

For the moment I want to leave landscape painting, with the young Samuel Palmer dreaming of his paradise on earth, because the deeper we move into the nineteenth century the more the black shadow of industry hangs over artists' visions of rural England. Not that it is often noticeable in their work; if anything its presence is usually felt by their determination to ignore it, rather like photographs advertising country cottages that manage to avoid showing the gas-works, the sewage farm, the municipal rubbish-tip and the dual-carriageway. A lot of Victorian art is like that.

Meanwhile I want to look at the land itself—or, rather, those bits of land that were transformed from wildness into art during roughly this same period of English history.

NATURE AND
GARDENS

All the artists I discussed in the previous chapter set down on canvas various ideal landscapes for man to imagine himself living in. Not surprisingly those privileged to own the real landscape were roused to alter it until it resembled those ideals. Artists showed them how. Landowners wanted their gardens and estates to look like a picture. They wanted to live in a work of art. And no country has done more to develop this art of landscaping nature than England.

What is more, it seems unlikely to be a coincidence that in England ownership of property as a basic human right was proclaimed earlier than anywhere else in Europe. The two are closely related. In so many aspects of English life property has long been what has defined a man, given him status and worth. The history of the English novel is one illustration of this national preoccupation. The issue 'Who owns England?, and what rights and privileges accrue to those who do?' runs right through the novel from Fielding to Thackeray, from Elizabeth Gaskell to Iris Murdoch.

Right to property was one of the key issues in the Cromwellian debates that followed the English Civil War. The view expressed by the idealist group known as the Levellers was that such a right was given by 'Law of Nature'. So, nature was actually considered to have a law entitling an Englishman to own it. The seventeenth-century philosopher John Locke embellished the Levellers' argument. Man, he maintained, had a right to what he could produce, and to whatever land he was capable of working in order to produce it. In Locke's view, a government's basic responsibility was to protect that right.

It is symptomatic of the mood of post-revolutionary England that the opposite view expressed by Thomas Hobbes—namely that man has *no* right of property unless a government awards it—was condemned by the Cromwellian parliament as unappealing and unacceptable.

That seventeenth-century 'Law of Nature' entitling an Englishman to a piece of property by natural right has had a very long arm. Anyone who gazes out of an aircraft window as his plane approaches Heathrow, or Manchester, or Newcastle or wherever, can observe how the ideal of a small piece of land as a basic human right has left an indelible mark, in the form of a million carefully tended back gardens, the like of which you will see nowhere else in the world.

The landscaping of nature, then, is both the most exclusive and the most popular of the arts. Stourhead or Sidcup—it is really only a matter of scale! Ideals of classical order and serenity. Romantic retreats. Where man most naturally belongs. Open-air theatres of the elements. Places fit for God to walk. You will find them everywhere you look.

If we go back to the earliest years of landscape gardening in England it is obvious that very few people were in a position to indulge in such pleasurable visions. The Levellers and John Locke were debating about the rights of people to grow turnips, not cultivate the art of topiary. The average smallholder in pre-industrial England had no time or room for the aesthetics of gardening as we know it today. It was only the aristocrats who had land to spare to practise all this improvement of nature: so naturally it is the great historic estates and the gardens of stately homes where those visions of England came to be applied to the landscape itself.

OPPOSITE **10** Levens Hall, Cumbria. *c.*1690. The only seventeenth-century English topiary garden to survive intact.

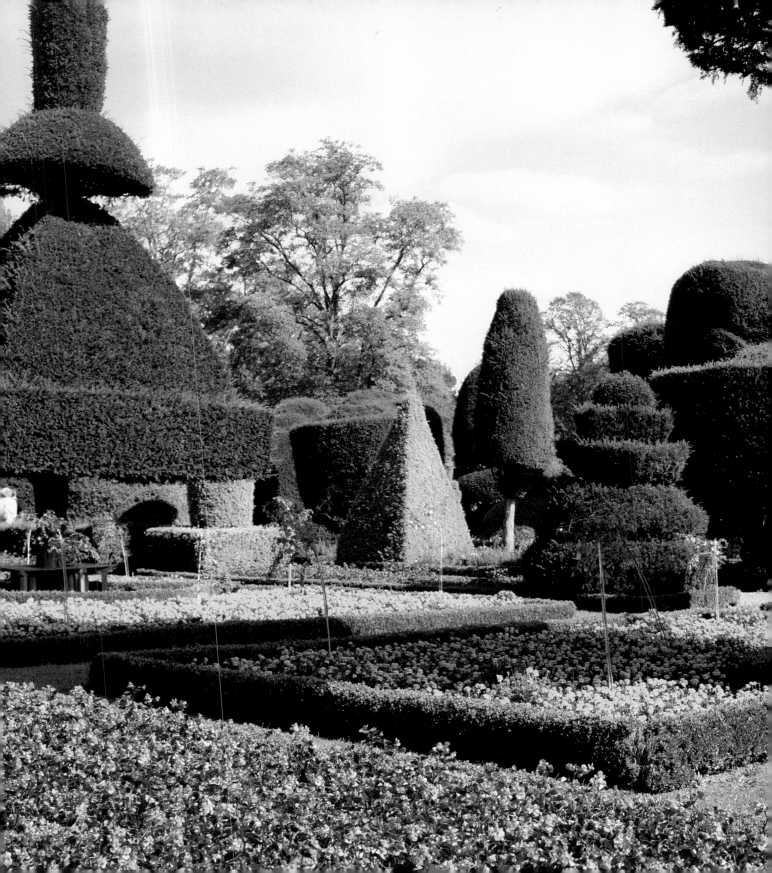

The topiary exhedra (now lost) in the gardens of Hartwell House, Aylesbury. Oil painting by Balthasar Nebot. 1738. Buckinghamshire County Museum.

Four gardens, created at different times over a span of four centuries, illustrate particularly clearly what various and changing visions people have had in this country of what nature is supposed to be, what nature has stood for, and how it has related to man.

The earliest of the four is at Levens Hall in Cumbria: an enchanting place in an enchanted region of England (Plate 10). The craggy chunk of Elizabethan manor-house is set back a short distance from the River Kent in the last few miles of its meander south-west towards Morecambe Bay and the Irish Sea. The Lake District lies a short distance to the north-west, and the landscape between is littered with miniature versions of the high peaks thrusting up out of the woods and fields.

The fame of the Levens Hall garden rests on its topiary—the most celebrated in England and the earliest to survive in its original form. For the past three centuries, ever since a Frenchman by the name of Beaumont laid out the garden in 1690, trees of box, and dark or golden yew, have been clipped and shaped into coronets, birds, pyramids and what look like gigantic chess-pieces.

Beaumont was a highly fashionable garden designer in England during the reign of William and Mary. He may have been a pupil of the great André Le Nôtre, the creator of Louis XIV's formal gardens at Versailles. Certainly the belief that he was helped Beaumont carry out an enormous amount of work for the English aristocracy up and down the country, virtually all of which (Levens excepted) got swept away when this particular fashion was replaced by quite a different vision of landscape in the eighteenth century.

But at Levens you can still walk straight into a seventeenth-century fantasy of nature—admittedly now grown beyond Beaumont's wildest ambitions. It is a vision of order, of nature under the tightest control. Just as a child's mind was shaped by Latin and logic, so nature was shaped by scissors and shears.

The very last thing an English landowner of the seventeenth century would have

Detail from an
eighteenth-century oil
painting of Dixton
Manor, Gloucestershire
(fourteenth century).
Cheltenham Art
Gallery.

dreamt about was providing himself with an environment of nature in its raw state. This would have been as unthinkable as inviting naked savages to inhabit the place. Nature was something 'out there', and to be kept 'out there'. He wanted a buffer between himself and the untutored world. More than this, he wanted an environment which would evoke the intellectual setting that his classical education taught him to aspire to—namely, the gardens of ancient Greece and Rome, where the early philosophers and poets mused, discoursed and created the most perfect civilization—as he believed—known to man.

The source of this vision was not art, in this case, but literature. Knowledge of classical villa gardens came to be transmitted chiefly through the Latin writings of Pliny the Younger, who owned several and describes them at length in his letters. 'You would fancy', Pliny writes of his Tuscan villa, 'that you were looking on the imaginary landscape of a first-class artist; such a harmonious variety of beautiful objects meets the eye wherever it turns.' And later:

> From the terrace you descend by an easy slope to a lawn and on each side of the descent are figures of animals in box facing each other. You then come to a pleasance formed of soft acanthus. Here also there is a walk bordered by topiary work and further on there is an oval space set about with box hedges and dwarf trees.

Pliny's accounts of life in the Roman era were avidly read by Renaissance scholars more than a thousand years later, and his description of Roman villa gardens formed the most valuable source of ideas for Renaissance gardens in fifteenth- and early sixteenth-century Italy. The architect Leon Battista Alberti laid down rules of garden design in his celebrated treatise on architecture, *De re aedificatoria*. The overriding principle was harmony—the key to beauty. Laurel, yew and cypress were recommended, and topiary, at least in the form of the owner's name carved in box.

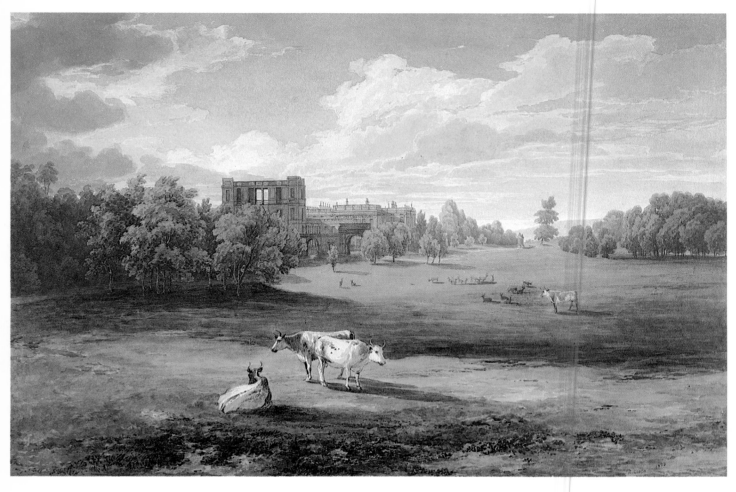

ABOVE AND OPPOSITE　**11, 12**　Chatsworth House, Derbyshire: watercolours by William Cowen showing the Capability Brown landscaping which transformed much of the original formal gardens, and swept away an entire village. *c.* 1830.

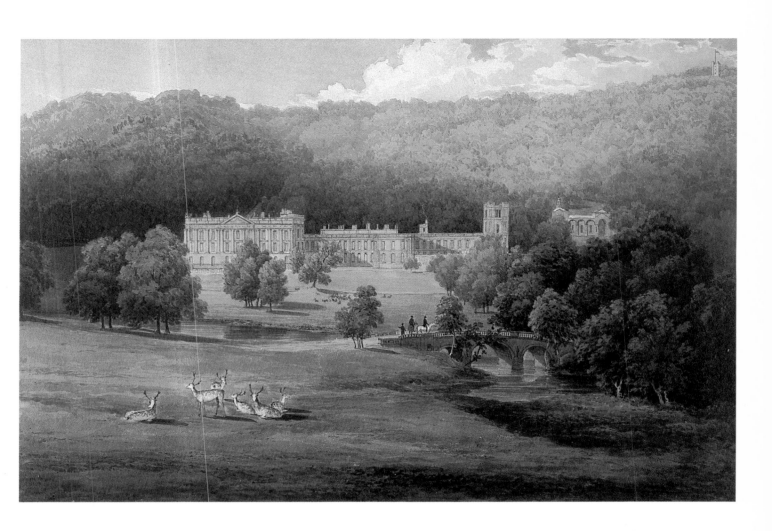

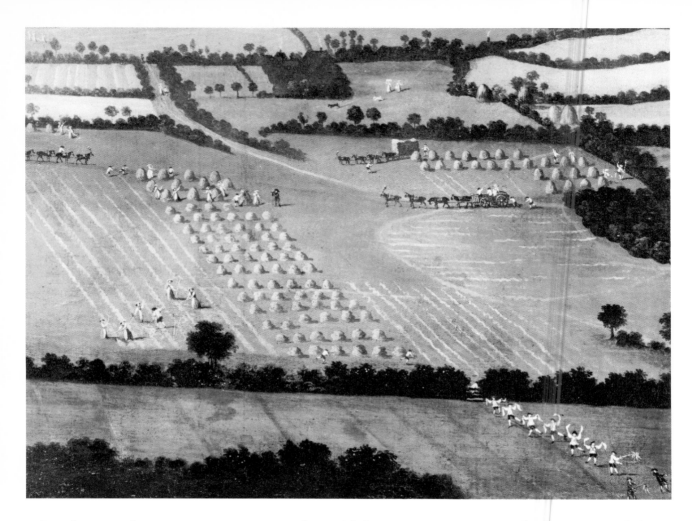

Eighteenth-century oil
painting of the
countryside around
Dixton Manor,
Gloucestershire.
Cheltenham Art
Gallery.

Here was the model for seventeenth-century England. Just as a scholar in
Renaissance Italy wanted to be a man of classical Rome, so a well-educated English landowner
wanted to be a Renaissance man. The topiary garden at Levens Hall is a remarkable survivor of
that nostalgia for a place in the classical sun.

But imposing rigid discipline on nature extended beyond the pruning of trees. At
much the same time as Beaumont was laying down the topiary garden at Levens Hall, another
Frenchman, by the name of Grillet, was creating one of the most spectacular features of any
English garden for the First Duke of Devonshire in the grounds of Chatsworth House in Derbyshire.

This was the Great Cascade. Today it is the one major survivor of the original
formal garden laid out for the first duke in the 1690s. Grillet built a long stone staircase into a
slope behind the house. At the top he erected a classical temple-cum-fountain, and here he set a
series of taps so that the water could be made to gush out through the mouths of stone beasts and
down the hillside over a flight of steps variously carved to create different water-patterns as it
flowed. The duke could gaze out of his window—as the present duke still can—and on command
watch a magnificent display of nature's powers firmly in the hands of man.

Here, as at Levens, was a man-made 'natural' environment which echoed the
gardens of Renaissance Italy—most obviously in the case of Chatsworth the famous water-
garden of the Villa d'Este at Tivoli, outside Rome.

So far, at Levens and at Chatsworth, the ideal landscape to live in has been one in which nature is the slave of man. And this determination to keep her under tight control must mean that nature in the wild was considered in seventeenth-century England to be extremely threatening—an unmapped wilderness where a man could get attacked, lost, battered by the elements, or starve to death. Had this ideal and this fear persisted, it is quite possible that there would have been no art of landscape painting in this country to speak of, and no art of the English garden as we know it today. The existence of both depended upon a fundamental change of attitude, and this in fact took place within half a century of the completion of the Great Cascade.

People began to see coherence and beauty in nature as she was. This represented a change in man's personal relationship with the natural world in which he lived. Rather than seeking reassurances from nature only when it was the progeny of his own intellect, he began to find spiritual comfort in the very naturalness of the world about him. No longer a wilderness, it was now a pure and healing place, a piece of God's perfect creation, the Garden of Eden before the Fall. Nature was welcomed in, instead of being kept out.

Here is the most important moment in the story of the English relationship to landscape, and of the art that sprung out of it. And it completely altered the English idea of a garden. The wittiest and most feared writer in England, the poet Alexander Pope, could now hold a noble lord's traditional garden up to ridicule:

> Two Cupids squirt before; a Lake behind
> Improves the keenness of the Northern wind.
> His Gardens next your admiration call,
> On ev'ry side you look, behold the Wall!
> No pleasing Intricacies intervene,
> No artful wildness to perplex the scene;
> Grove nods at grove, each Alley has a brother,
> And half the platform just reflects the other.
> The suff'ring eye inverted Nature sees,
> Trees cut to Statues, Statues thick as trees.

No wonder most of the tasteful geometrical gardens of England were torn up by the middle of the eighteenth century.

The indefatigable Lancelot 'Capability' Brown included Chatsworth among the many grand English estates he undertook to transform into the new model of naturalness—which was not natural at all, of course, though it gave landowners the pleasing impression that it was (Plates 11 and 12). Now instead of the parterre, the new ideal environment was the park. And for the Fourth Duke of Devonshire 'Capability' Brown swept the park right up to Chatsworth House itself, sweeping away an entire village in the process so that his lordship's panorama of nature should not be spoilt by a glimpse of humble man.

The eighteenth-century revolution in the Englishman's relationship to nature has

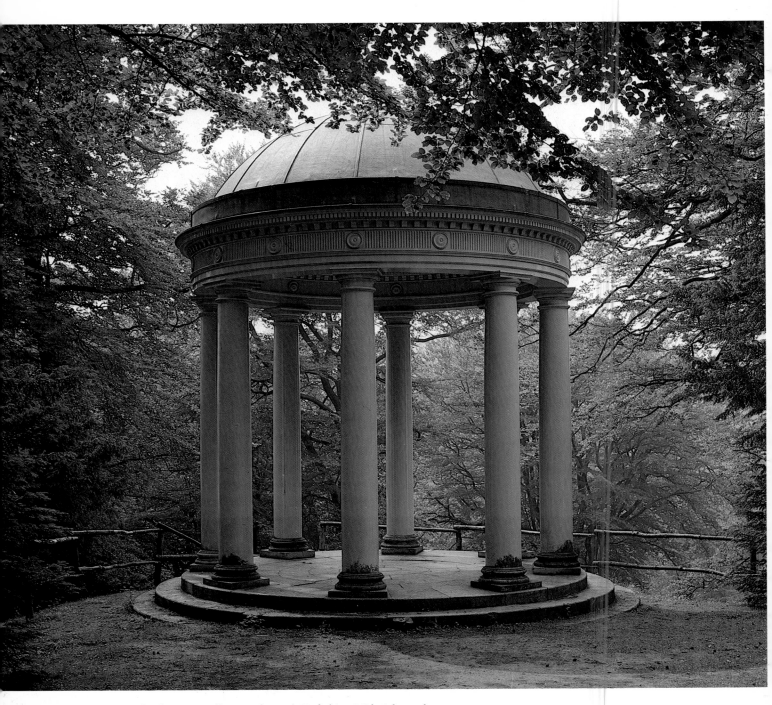

13 The Temple of Fame, Studley Royal, North Yorkshire. Mid-eighteenth century.

OPPOSITE 14 Fountains Abbey, North Yorkshire. The ruined Cistercian abbey was purchased by the owner of Studley Royal in 1768 and became the focal point of his garden.

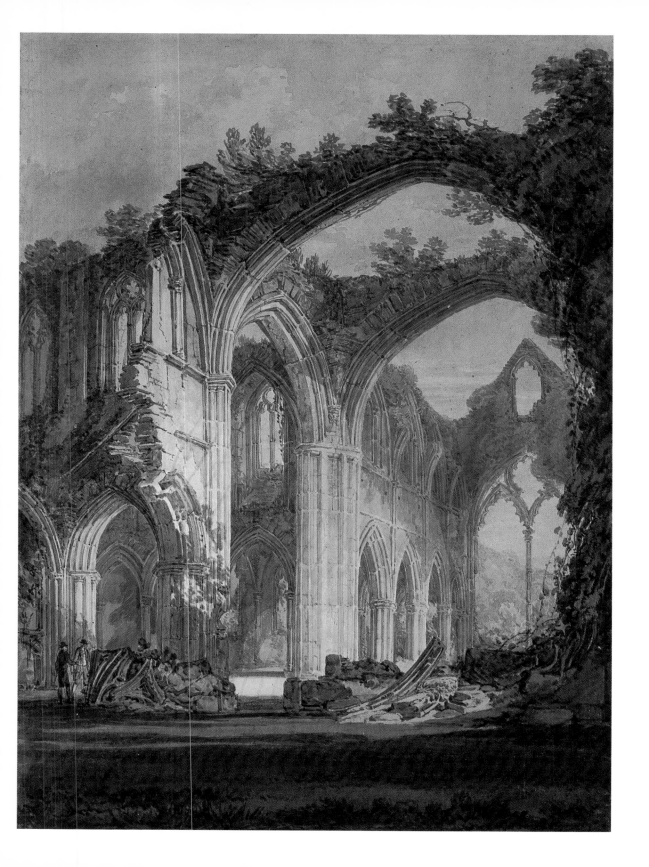

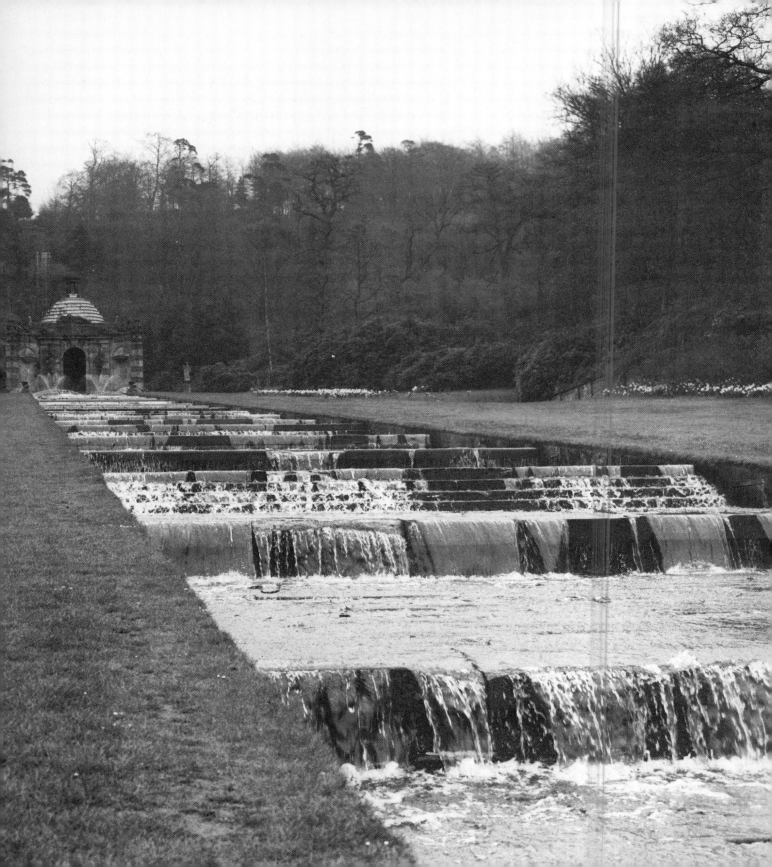

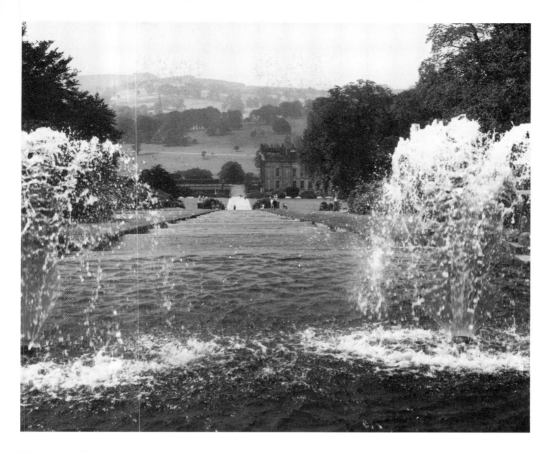

OPPOSITE AND LEFT
The Great Cascade,
Chatsworth House,
Derbyshire.

the spirit of nature: it was an intermediary between Aislabie and God. He could hardly have asked for anything more.

The fact that Fountains Abbey was a ruin was important. Ruins had a special aura for the eighteenth-century Englishman, largely because in the minds of the educated rich they possessed associations with the ruins of Ancient Rome: the Colosseum, the Forum, the Appian Way, the great aqueducts. Ancient Rome represented the Golden Age, and its ruined state merely enhanced its glamour for those wealthy young men who made the Grand Tour in order to pick up some Roman gold-dust on their boots. William Aislabie had been one of them—in the very year that his father's political fortunes had exploded with the South Sea Bubble.

So, in the eyes of eighteenth-century English gentlemen the perfect landscape was one that evoked the grandeur of the landscape of Ancient Rome. Had it been possible to transport the Arch of Titus or the Colosseum back home, stone by stone, I feel sure they would have done it. But not even an English milord could manage that. Travellers on the Grand Tour had to be content with paintings which recorded those monuments, or with relatively modest artefacts such as bronzes, pottery and stone statues. As a result, what seems to have happened is that ruins at home were awarded the same glamour as those associated with Ancient Rome. And of course the prime candidates—because they were impressive and so numerous—were the great abbeys that had been destroyed by Henry VIII.

What began as an extension of educated taste developed, by the end of the century, into a fashion. The English abbeys became a stock-in-trade for virtually all the English watercolour painters, and by the early nineteenth century there was scarcely a ruined abbey in England that had not become the focus of the Romantic artist's vision of the ideal English

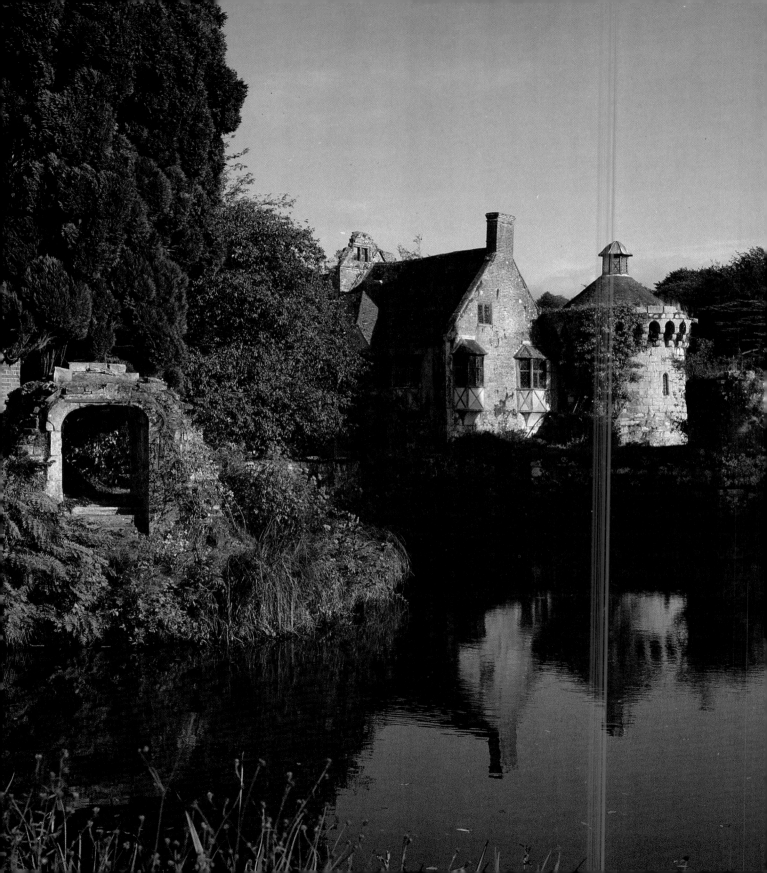

landscape. Girtin, Turner, Constable, Cotman, Cox: these and numerous other painters all spent periods of their lives trekking the countryside to record the special *frisson* provided by a monastic ruin (Plates 15 and 16).

Their reasons for doing so were precisely the reasons why the elder Aislabie had been so anxious to incorporate Fountains Abbey into his own garden. They were ruined, so they had a kind of magic about them. And they were generally set in open countryside as though they were part of nature itself. The very spirit of nature.

In the hundred years or so since the topiary garden at Levens and the Great Cascade at Chatsworth, a special relationship had developed between man and nature. In the early eighteenth century this was a rather cool, cultured relationship. Later in that century it became self-indulgent and 'poetical'. Then in the nineteenth century it grew into a romance: the wildness of human passions was felt to be matched by the wildness of nature. And the role of the English ruin follows this progression. By the nineteenth century it is as if this passionate relationship with nature could not be consummated without a ruin in attendance. If you did not have one—and most people did not have Fountains Abbey at the end of their garden—then you created a ruin.

This was precisely what was done by Edward Hussey on his family estate in Kent, Scotney Castle (Plate 17). Today this is among the most perfect English gardens I know. Now owned by the National Trust, it is set beside a small lake, with streams, bridges and islands stretching along a secluded valley overhung with ancient trees and colossal rhododendrons. It feels like the epitome of England's green and pleasant land.

The castle is right on the lake, which curls round it acting as the castle moat. It had been built as a fortified house in 1378, during the reign of Richard II, and subsequently enlarged. Edward Hussey inherited it as a boy in the early nineteenth century, but his mother found the place intolerably damp and refused to live there. Hussey, when he came of age, returned to Scotney and built a new family house on higher ground. But rather than demolish the castle he decided—true to the spirit of the century—to pull it half-down, leaving the relic as the romantic focus of his lakeside garden. The result is this most elegant marriage of decay and fecundity: man's works in ruin amid the triumph of nature.

When the topiary garden at Levens Hall was laid out, to feel at home with nature it was necessary to control it by forcing it to counterfeit man's art: trees made to look like castles, coronets, pyramids. Less than two hundred years later, to feel at home with nature required just the opposite. She must be encouraged to grow free, and it is man's art—man's house—that is made to counterfeit the wildness of nature.

It has been an extraordinarily varied vision of landscape as the environment of man—not a simple one to comprehend because what people have expected of nature has never stayed the same. But neither, of course, have people. The art of any nation reflects how that nation has seen itself—what it has valued, what it has cherished, and what it has dreamed about. So, how have works of art shown us living in nature, and with nature?

OPPOSITE
17 Scotney Castle, Kent. Late-fourteenth-century, with mid-nineteenth-century gardens.

NATURE AND THE
COUNTRYMAN

nglish landscape painting is a mirror of the English love of nature. But it is also a mirror of the Englishman who is in love with nature, so much so that he has sometimes felt himself to be an actual part of it. By and large the kind of paintings I have been writing about so far present landscape, however deeply felt, as external to man. Nature observed. Here is man and out there is the rest of God's creation, and the lines separating them are clear. Sometimes, though, the lines become blurred. Constable, for example, perhaps because he is at heart a countryman, repeatedly transcends the pictorial view of the countryside as something outside man, and describes man and nature as one and the same thing. His bargees, his farmers, his fishermen inhabit the landscape just as naturally as his horses and sheepdogs.

The kind of English landscape painting where this identification of man with nature is particularly clear is the open-air portrait, which if not exactly an English invention is certainly a form of portraiture that English artists made very much their own. The nation which has so consistently proclaimed ownership of property to be a basic human right (see Chapter Two) not surprisingly displays its landowners in the proud possession of their lands.

What is more, there is a particular moment in English painting when this identification of man with nature takes place. It is precisely the moment in the second quarter of the eighteenth century when the English formal garden, designed to keep nature out, begins to give way to the landscaped garden designed to welcome nature in. Before this time the open-air portrait had been a rather lifeless affair. Painters were fond of taking an imaginary balloon trip in order to create a sort of aerial map of a landowner's property—field by field, tree by tree—and then adding little stick-like figures of the owner and his family posturing in front of the big house. They all tend to be relentlessly the same, like property deeds.

One of the first artists to permit a glimmer of life into this formal scenery was John Wootton, who was born about 1677 and trained in the Dutch school of landscape painting—which accounts for his work possessing some feeling for what the countryside was really like. Not that he had much opportunity to display it since most of his employment during the early years of the eighteenth century consisted of commissions by the sporting aristocracy for recording race meetings at Newmarket.

Later, however, Wootton managed to free himself from the demands of the turf and became a landscape artist of considerable skill and—more to the point here—a delightful painter of open-air portraits. These tend to be painted according to a fairly rigid formula but in them we have the first glimpse of English society concerned to identify itself with a particular piece of landscape which is their property.

The panorama is sufficient to embrace the owner's lands, with the stately home more or less in the centre background; but the balloon is lower now and the landscape is real, not simply a map. In the foreground the land rises steeply, and assembled nearby is the family in question. They invariably tell us, if we look closely, how we are supposed to read the picture.

My own favourite open-air portrait by Wootton still hangs—as so many of them do—in the house for which it was originally painted: Squerryes Court, near Westerham in Kent,

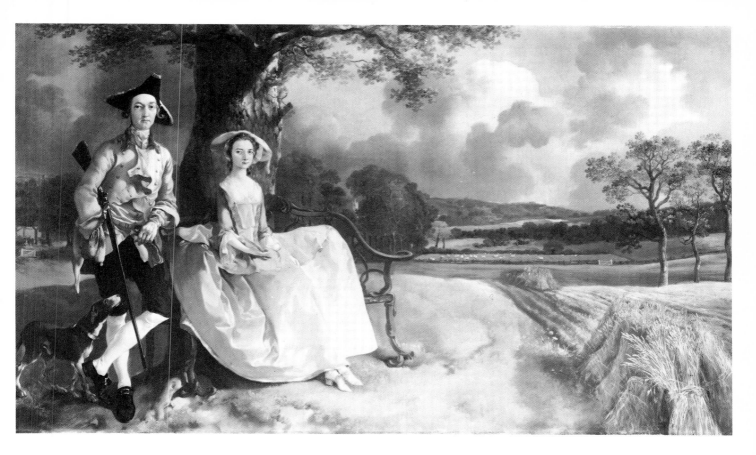

Thomas Gainsborough, *Mr and Mrs Robert Andrews*. Oil. 1749. London, National Gallery.

now open to the public. In Wootton's painting the house looks spankingly new and indeed it is, and this is why the owner, John Warde, is standing with an important air in front of it (Plate 19). He has recently bought the estate, rebuilt the property, created an ornamental lake, and now in 1735 has employed Wootton to record these accomplishments.

His younger children sit elegantly on the grass with their pets. His eldest son and heir is standing proudly before an avenue of trees up which he will ride one day to take his father's place. And here is John Warde himself, his wife and son both looking up at him: no question about who is in charge. With a gesture of the hand he is clearly indicating to us, 'Look! All this is mine! My family! My house! My land!' At the same time it is a gesture which seems to suggest that he is not really all that important without the land that is his. Wootton's paintings are about property and ownership. But they do have this glimmer of understanding that a man's land is a key to his identity—that he is rooted in it, and it makes him what he is.

By the middle of the century this identification of man with nature has become much more explicit, and it is another painter of open-air portraits, Arthur Devis (born 1712), who underlines it over and over again. Like Wootton, Devis evolved a formula—or several formulae—for painting his demure-looking clientele in the setting of their houses and estates. One of these is Wootton's practice of standing the landowner with his family in front of the family mansion, all set up stiffly on the grass like fire-screens.

But it is another Devis formula which is much more innovative, because it dispenses with the central feature of the family mansion altogether. Instead, Devis sets his English landowners firmly amid their estates. We do not know what instructions the sitters gave the artist, or who selected the precise location. What is interesting is to notice how often his elegant

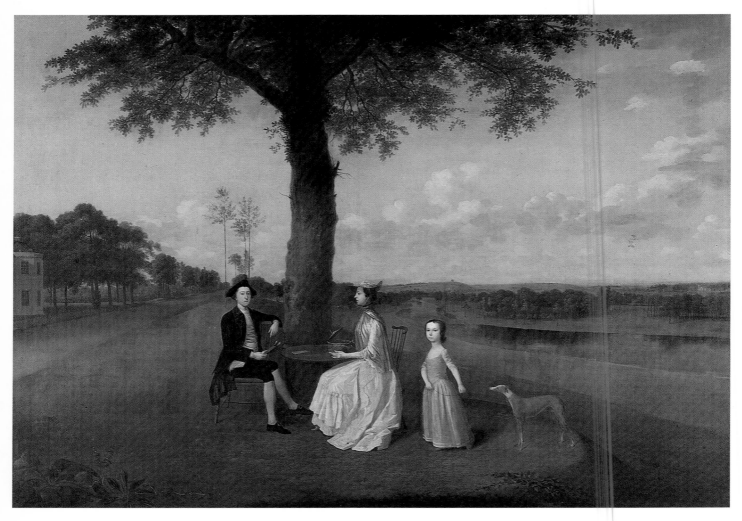

18 Arthur Devis, *Henry Fiennes Clinton 9th Earl of Lincoln with his Wife Catherine and Son George*. Oil. *c*.1751. Private Collection.

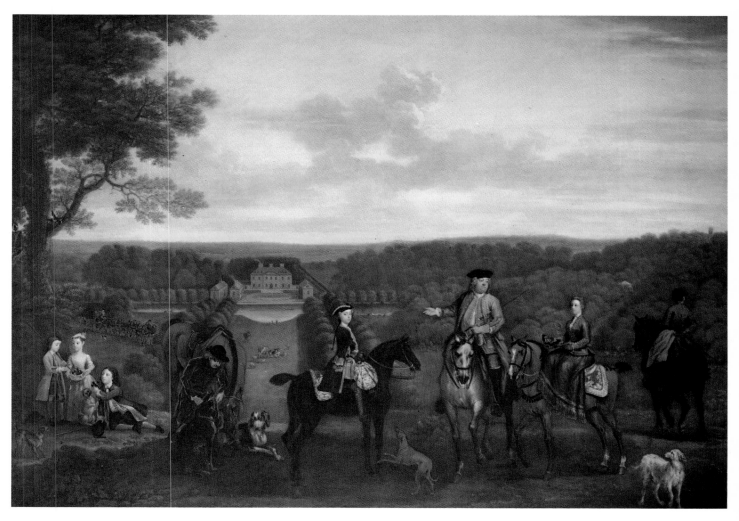

19 John Wootton, *The Warde Family*. Oil. 1735. Squerryes Court, Westerham, Kent.

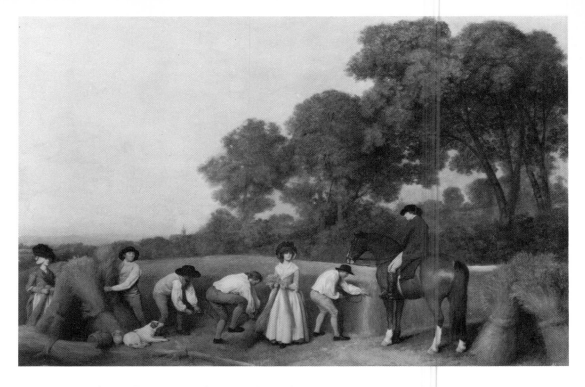

George Stubbs,
Reapers. Oil. 1785.
London, Tate Gallery.

gentry pose in front of a massive oak-tree in the midst of their acres. Its solid trunk stands guard over these frail-looking figures, and its branches spread above them like a protective umbrella (Plate 18).

This composition is echoed by the young Gainsborough (fifteen years Devis's junior) in a number of open-air portraits he carried out during his early days in Sudbury and Ipswich in the 1840s and 1850s, when he was earning his living painting well-to-do gentlemen-farmers in East Anglia. The most celebrated of these is the portrait of Mr and Mrs Robert Andrews, now in the National Gallery. This is supposed to be a wedding portrait, or at least a portrait of newly-weds. You might have expected that a newly married couple would wish to go down to posterity against the background of the family house or elegant garden. Not a bit of it. What Robert and Frances Andrews are proud of is their farm; and they have made sure that Gainsborough paints them well to the left of the picture the better to show it off.

Their farm is a reflection of what they are. It is well kept, prosperous, as natural-looking as possible. He has a gun slung under one arm, and a gun-dog by his side. And look where they have chosen to pose for their portrait. Right under the embrace of a venerable oak. This is how Farmer Andrews sees himself—as an oak of Old England, strong, dependable, and rooted in the particular patch of England that is his. Had he been able to foresee that more than two hundred and thirty years later the oak would still be there—looking not so very much older than when Gainsborough painted it—I feel sure he would have felt a surge of pride. What he stands for is durable even if he is not.

There is no artist in eighteenth-century England who perceives this human bond with nature more clearly than Gainsborough's great contemporary, George Stubbs. Now that he has been relieved of the diminishing label 'Mr Stubbs the horse painter', it becomes possible to see his art as a shrewd account of pre-industrial England and a coherent vision of country life.

In Stubbs' open-air portraits and conversation pieces the bond with nature is so close that the answer to the question 'What is man?' is invariably the same as it is to the question

'Where is man?' He has no identity without the environment in which he lives. The land provides him with his food, his pleasures, his home and his livelihood. More than this, he has shaped the landscape to reflect what he is and what he values. When Stubbs' gentleman looks around him at his slice of nature he sees himself there—everywhere. Love of nature has become a kind of self-love because everything he cares for is reflected in it. And it is this perception which makes Stubbs one of the greatest of English painters. He turns an understanding of nature into an understanding of man. He sees how man is what he is through his intimate relationship to nature, and he sees how nature itself has been groomed in man's image.

Because of Stubbs' exceptional skill at painting horses his clientele, not surprisingly, were the English sporting aristocracy (Plate 20). They were the lords of the turf—men responsible for the foundation of the Jockey Club in 1750, for the first steeplechase in 1752, the first St Leger in 1778, the Oaks in 1779, the Derby in 1780. They were patrons who knew and cared a great deal about horses, but rather little about art. They were more at home at Newmarket than on the Grand Tour.

George Stubbs,
Reapers. Oil. 1783.
Detail. Banbury,
Upton House (Bearsted
Collection).

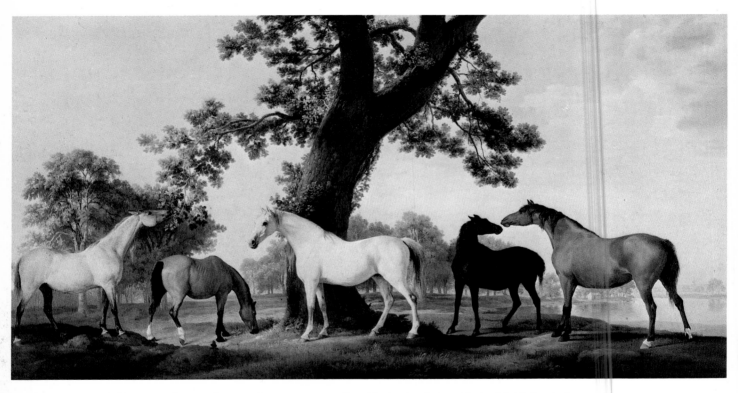

20 George Stubbs, *Mares by an Oak Tree*. Oil. 1764. Ascott, Wing, The National Trust (Rothschild Collection).

OPPOSITE 21 George Stubbs, *Haymakers*. Oil. 1785. London, Tate Gallery.

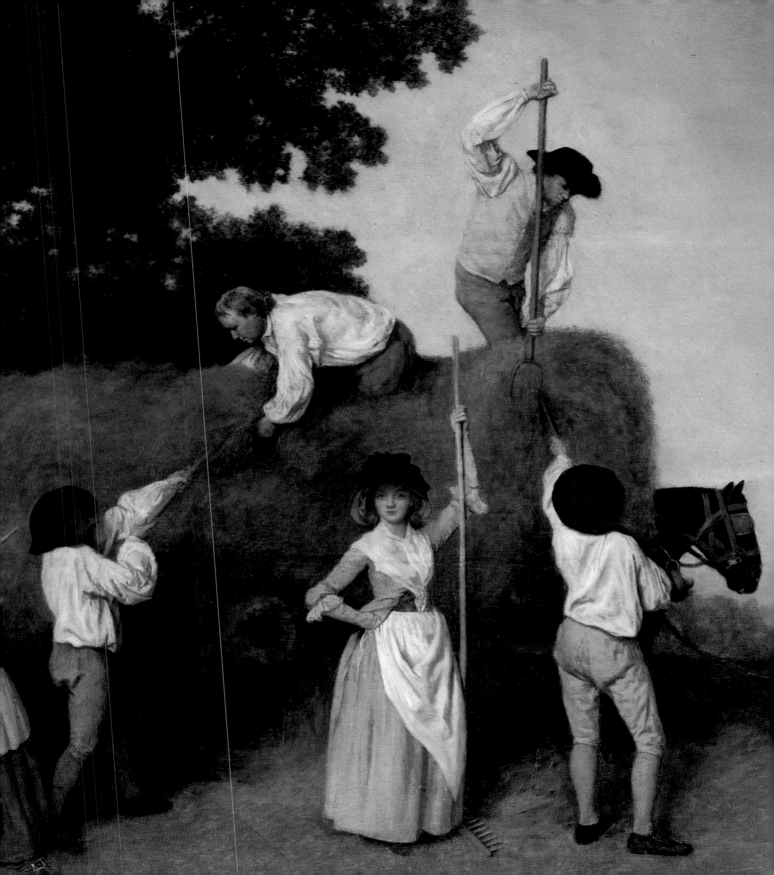

Stubbs' fascination with animals has at heart very little to do with the rural sports which occupied so much of his patrons' time. He rarely even paints a sporting event. His interests lie elsewhere: in the way people dress, behave, present themselves to the world, in their values, the social system they obey, their various prescriptions for an ordered world.

Stubbs gazes at the panorama of English country life—from aristocracy at their leisure to gentlemen-farmers with their gun-dogs and carriages, to jockeys, stable-boys and farm-labourers going about their tasks. He sees in all this a harmony, a structure and a great peacefulness; and it is these qualities that pervade his art. There is no strife and no callous exploitation. Man may kill for food or hunt for pleasure, but these are always presented as consistent with the laws of nature which allow one animal to prey upon another: violence does not in itself cause any dislocation of natural law.

The basis of this harmony between man and nature is his dependence upon the land. The earth is what the countryman is tied to. When you look at Stubbs' portrait of a Lincolnshire landowner, Sir John Nelthorpe, in the 1770s (Plate 22) you can see straightaway why we describe people as 'down to earth', 'coming back to earth', or 'an earthy type'; why we refer to someone as 'having his feet on the ground'.

Here he is on his farm with his gun and his dogs. His fields spread around him. Beyond is the town of Barton, of which he is squire, and the church where he will have the most

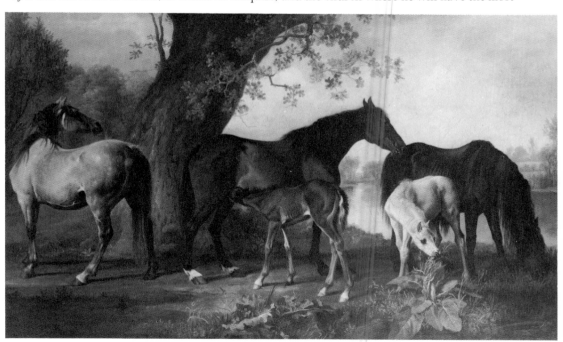

George Stubbs, *Mares and Foals by a Stream.* Oil. 1763–4. Private Collection.

important family pew. In the far background runs the estuary of the River Humber which marks the boundary of his kingdom. No artist painted the prosaic aspects of human beings more understandingly or more lovingly than Stubbs. Sir John is identified entirely in terms of where he lives and what he does on his land.

In Stubbs' vision of order the most natural use of the land is for farming, and a well-run farm is like a well-run family. Everyone knows his place, and the result is peace, nourishment and prosperity. In Stubbs' agricultural pictures the hardships of farming life for the labouring class in the eighteenth century go unacknowledged; presumably they are considered a mere malfunctioning of the system. Stubbs shows an ideal of the social order at work, as the Age of Reason held it to be, and saw no impediment to its remaining so for ever. All was for the best in the best of all possible worlds.

In the midst of this earthy idyll now and again Stubbs permits himself an ever-so-discreet twinkle in the eye. It is one of the charms of the man. Not quite everybody is engaged in worthily fulfilling his role in the natural order of things. His grooms and jockeys indulge in sly glances. There is a hint of private jokes being swapped, even a snook being cocked. Stubbs is a painter to go up to very closely to catch the irreverent details. These do not disturb the sober harmony of the occasion, but they are there like the murmur of barely audible gossip at some formal gathering.

George Stubbs, *Mares and Foals*. Oil. 1762. Private Collection.

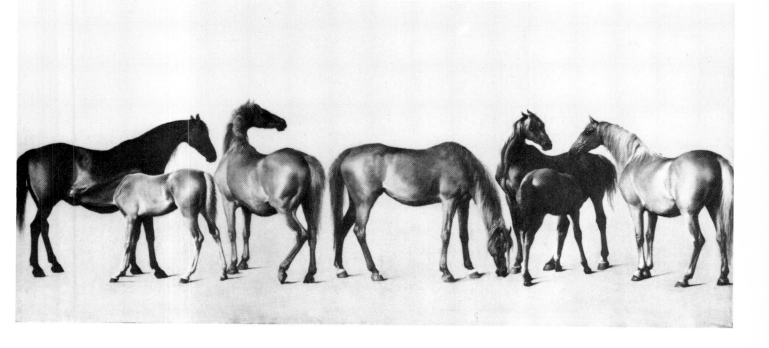

My own favourite twinkle in Stubbs' eye is the girl who stands in the middle of the picture called *Haymakers* (Plate 21). She is looking straight at us with one hand jauntily on her hip and a quizzical expression on her face. Why is she looking at us— or at Stubbs? In this perfect order of things should she not be loading the hay-cart like the others? Perhaps Stubbs, now in his impoverished old age, included her to make the picture more saleable. Perhaps she just turned to gaze at him while he was sketching the scene. What comes across is a very mild touch of sauce. And that tall wooden rake she is grasping so very vertically: is she thinking only of agriculture? And, indeed, is Stubbs?

Yet these are only whispers. Not for Stubbs the townees' fantasies of country life painted by Boucher and Fragonard, with *décolletée* maidens harvesting grapes as if waiting to be plucked like grapes, and rosy shepherdesses ready to be led like sheep. By contrast to these rural flights of fancy that were the vogue in eighteenth-century France, Stubbs' account of Englishmen and nature can look somewhat four-square and—I have used the word before—prosaic. There is, however, one aspect of their lives which Stubbs sees as magically lyrical—something that transforms these stolid gentlemen into men of altogether deeper sensibilities: the Englishman's love of animals. It is in the way man deals with animals that his finer feelings are revealed; and it is in the way Stubbs displays them to us that we understand what these feelings are.

To Stubbs animals echo the social hierarchy to which man holds. They also stand for a host of different virtues. These virtues are ones that in language we commonly associate with animals, but in art there is no painter who has given such convincing form to these associations: the lion of matchless strength and bravery; the stag, swift and noble; the fox, cunning and clever, the most admired of adversaries; the dog, faithful, companionable, bred for special services, but with a wild streak that makes him not entirely servile—like the man himself who is 'a bit of a dog'.

And then the horse. In Stubbs' world the horse is the primary symbol. It is at the top of the animal hierarchy. In Stubbs' paintings everything in nature reflects the eighteenth-century countryman, but it is the horse which represents the things he holds most dear: breeding, pedigree, good schooling, discipline, elegance, stamina, fortitude, and on the race-course a desire to win, as well as less heroic qualities highly esteemed by the landed aristocracy— a certain uniformity, a sturdy reliability, even perhaps a certain dullness between the ears, and a safe absence of dangerous thoughts.

But, to Stubbs, horses are something else besides. He perceives that man's love of horses is evidence of a love of beauty. A French artist might have conveyed this by showing a man with a lovely woman, or perhaps a classical temple. Stubbs does it with horses. He paints them as the perfect creation of nature. And in the complex web of relationships between man and nature which he lays out on his canvases, it is his close relationship to the horse that represents man at his noblest. But for this sensibility Stubbs' Englishmen could be a bunch of Hoorah Henries. It is their love of horses which elevates these rather boot-faced countrymen to being men of finer feelings. It is as though horses were their collection of fine china: perfect examples of perfect taste.

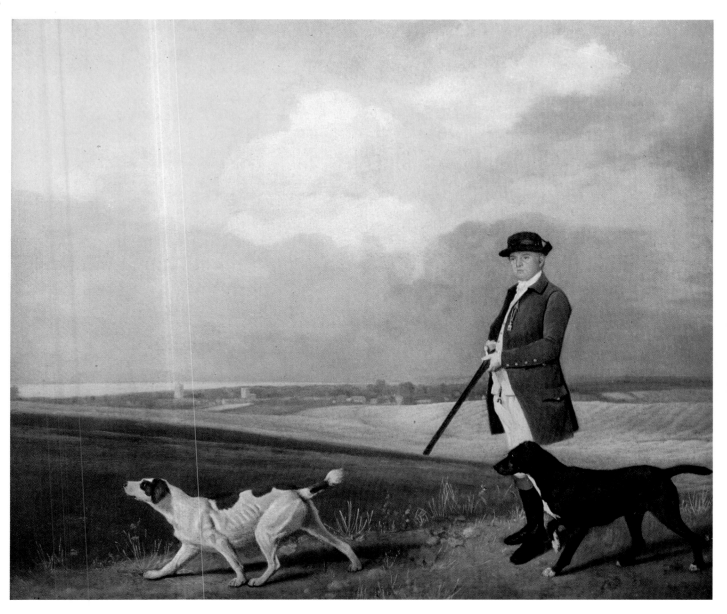

22 George Stubbs, *Sir John Nelthorpe out Shooting with Two Pointers*. Oil. 1776. Private Collection.

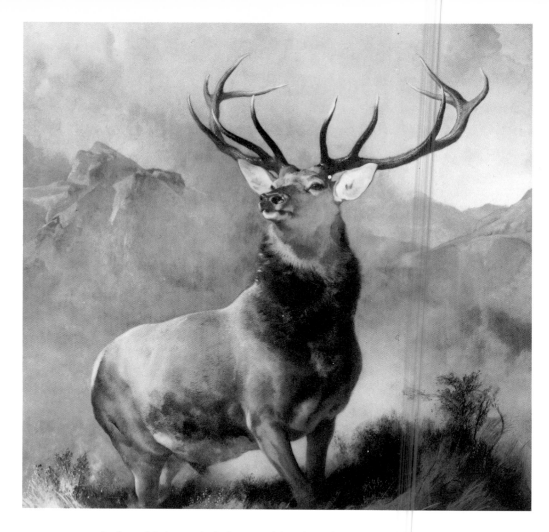

Edwin Landseer, *The Monarch of the Glen*. Oil. 1851. Private Collection.

In fact, this is precisely how Stubbs often chooses to paint horses—as an elegant frieze like an art collection displayed across a man's estate for us all to admire, and in doing so of course to admire the taste of the man who has collected them. Altogether, here is an enormously contented vision of England: relaxed and graceful. It always seems to be summer. It never rains. There are no rough winds, no ruffled tempers. Nature's order is man's order. Nature and man are in perfect harmony. And Stubbs is the most eloquent witness we have of that world.

Then, that world seems to disappear without trace. By the middle of the nineteenth century the evidence of art is of anything but a peaceful marriage between man and nature. It has become a squabble broken by tearful interludes.

Historians account for such dramatic changes in the intellectual climate of England according to their areas of expertise: the breakdown of traditional feudal hierarchies which bound English rural life in the eighteenth century; the upsurge of Romanticism in the early nineteenth century; the burgeoning of British imperialism; the impact of Methodism; the rude awakening from insular slumber brought about by the French Revolution and then by invasion threats from Napoleon. And, of course, the Industrial Revolution. In the context of man's relationship to nature, this seems to me the most powerful of all these instruments of change.

Again—as with pure landscape painting, as with garden design—the reaction of many artists and their wealthy clients to the shock-waves of industry was to retreat and pretend they did not exist. To retreat into a cloud-cuckooland in which nature is either sentimentalized—pretty milkmaids and baa-lambs—or awarded heroic status.

The artist who epitomizes this heroic view of nature is Sir Edwin Landseer, Queen Victoria's favourite painter. Where Stubbs sees man's life reflected in nature as something harmonious, civilized, on the whole gentle, nature shows Landseer quite a different side of man and quite a different set of human values. Like Lord Tennyson he sees nature 'red in tooth and claw', and he loves it that way. Here is Landseer in 1837, in his mid-thirties, writing about hunting to an enormously wealthy friend and patron, Lord Ellesmere:

> There is something in the toil and trouble, the wild weather and savage scenery that makes butchers of us. Who does not glory in the death of a fine stag? On the spot—when in truth he ought to be ashamed of the assassination. . . . Still, with all my respect for the animal's inoffensive character—my love of him *as a subject for the pencil* gets the better of such tenderness—a creature always picturesque and *never* ungraceful is too great a property to sacrifice to common feelings of humanity.

So, 'property', 'glory' and 'death' are finer, more masculine things than 'common feelings of humanity', which by implication are soft and weak and feminine. Nature is actually more powerful than feelings of humanity: it is savage and it makes savages of us all. With Landseer the real man warms to being turned into a butcher.

Here is a vision of man's relationship to nature so utterly at odds with the world of Stubbs that it is really quite hard to credit that the two painters were attracted to similar subject-matter and employed by the same class of landed aristocracy within a period of a hundred years of one another. To Landseer man is no longer dependent upon the land, tied to it and identified with it. He has become a predator, and the most successful predator of them all. Therefore he is master of the natural world around him, and he exercises this mastery by force of his superior strength, intelligence and skill. It is this that makes him a man, and the business of being a man lies at the very centre of Landseer's art.

Like Stubbs, Landseer sees the nature of human beings mirrored in the nature and behaviour of animals. But where Stubbs sees them merely as representing qualities he admires, Landseer goes much further and turns animals into human beings in disguise, so much so that his work as a whole resembles a kind of Victorian Animal Farm.

His principal idol is the dog. The dog is man's exemplar. His most faithful companion, the dog also acts out what Victorian man is too inhibited and 'civilized' to give expression to himself (Plate 23). Landseer's dogs sacrifice their lives for their master, tear the enemy to pieces, gaze adoringly at the queen. They are allowed a whole range of naked sentiments that would not be entirely proper for man himself to acknowledge.

Landseer's most sickening picture is *The Otter Hunt* (Plate 24). A pack of hounds is slavering round the central figure of a huntsman who is hoisting aloft the speared and writhing

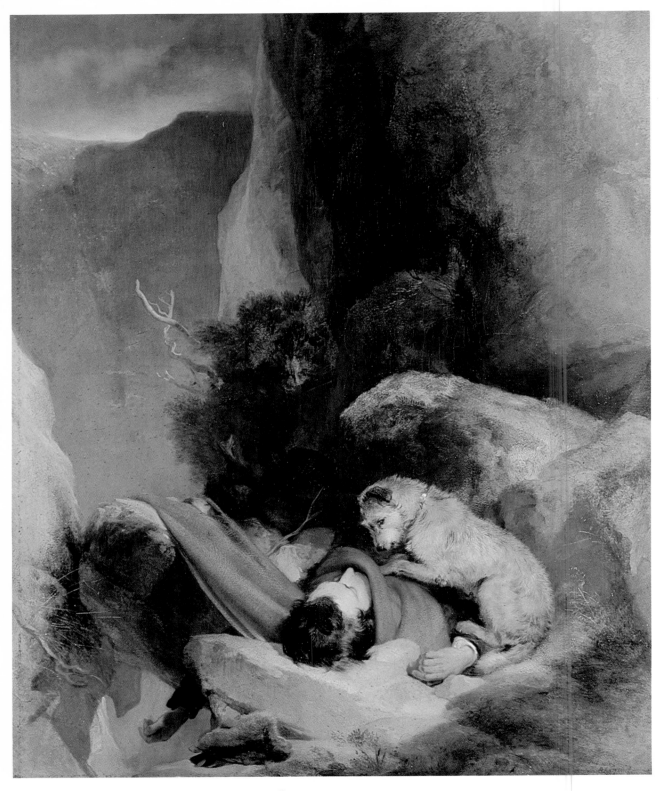

23 Edwin Landseer, *Attachment*. Oil. 1829. Private Collection.

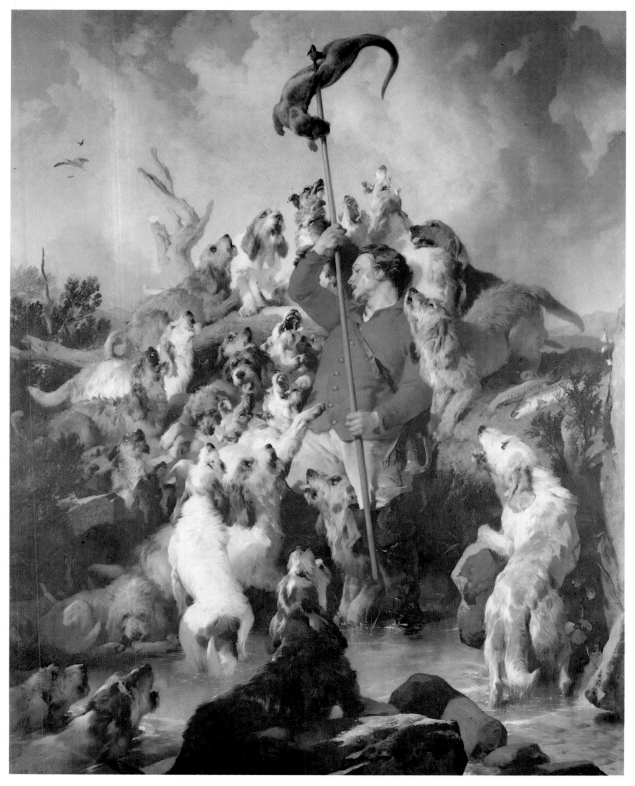

24 Edwin Landseer, *The Otter Hunt*. Oil. 1844. Newcastle upon Tyne, Tyne and Wear Museums.

body of an otter. What is sickening about it is not in the end the cruelty of the story. This could have been recounted as documentary realism, since spearing otters had long been the standard method of killing them, and nobody until the late nineteenth century thought twice about the feelings of an animal considered a vicious thief of man's food. No, what is much more revolting is the tone of heroic moral rectitude.

Landseer has painted the huntsman in such a way you might imagine he was earning the VC hoisting the regimental colours in the thick of battle. His face in profile is noble, his eyes are downcast, he is modest in the weariness of his exploits. But the dogs! All the blood-lust which our hero conceals snarls from their frantic jaws. The dogs say for him what he does not consider it decent to say himself.

To Landseer the dog is all things to all men, because it can be made to represent the Victorian ideal of femininity as well. One of Landseer's Highland scenes shows the interior of a humble croft in which another pack of dogs is lapping milk from a tub. One of them is suckling her puppies at the same time. And, lo and behold, seated nearby is a Highland mother giving her baby the breast. Again the tone is heavily moral: nature provides the good woman with the prototype of nurturing motherhood, and the good woman emulates nature.

Above all, the dog symbolizes the feminine ideal of selfless devotion to the male. Landseer's dogs wait eternally for their masters to return; they sit inconsolably at the grave-side; they endure and endure in attendance on the injured and dying. Sir Walter Scott's poem *Helvellyn* about a mountaineering accident and the terrier who kept guard over her master's corpse for three long months, inspired one of the artist's most tear-jerking tributes to this ideal:

> Dark green was the spot mid the brown mountain heather,
>> Where the Pilgrim of Nature lay stretch'd in decay.
> Like the corpse of an outcast abandon'd to weather,
>> Till the mountain-winds wasted the tenantless clay.
> Not yet quite deserted, though lonely extended,
>> For, faithful in death, his mute favourite attended,
> The much-loved remains of her master defended. . . .

It is perfectly easy to see why the whole of England cried over such pictures, and it is equally clear that only a Victorian could possibly have painted them. Sentimentality, like anger, is the pus of suppressed emotions. In Landseer, the Victorian artist *par excellence*, the emotional constraints of the era find their expression outside man, in the mirror of nature. Sentimentality on the one hand, sadism on the other: Landseer's sentiments invariably slip into these extremes. There have to be heroes, there has to be glory. There have to be victims, there have to be the tears that flow. Nature is an assault course to test the manhood of an Englishman.

And the greatest test, in Landseer's paintings, is man's hunt of the stag. Here is the noblest of all wild creatures native to Britain. And although in the most famous of the artist's works the stag stands triumphant as *The Monarch of the Glen*, we know from the whole corpus of Landseer's paintings that he will never be allowed to stay up there. The stag is the ultimate prey.

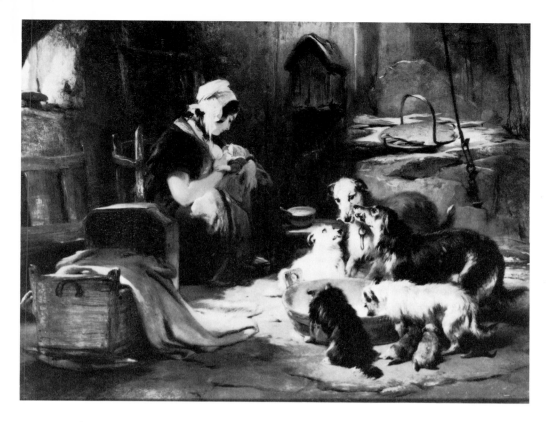

Edwin Landseer,
Highland Breakfast.
Oil. Exhibited 1834.
London, Victoria and
Albert Museum.

I suppose the Victorians—the most successful of all empire-builders—could not resist pulling down another monarch. The more they admired him, the more they were driven to destroy him, and the greater the test of manhood. 'Who does not glory in the death of a fine stag?'

There are only two creatures Landseer is prepared to spare. One is the servile dog. The other is the lion. He is not for pulling down because, after all, the lion is England. Hence the four enormous lions the artists was commissioned to make in clay (for casting in bronze) to complete the monument to Nelson in Trafalgar Square. They are the climax of Landseer's career, and as he struggled to complete the task he expressed the hope that he would 'neither disappoint . . . the country or the brave Nelson in my treatment of these symbols of our national defences.' Animals as symbols—again.

I cannot find a lot to love about Landseer. But he was a hero in Victorian England, and he brings to a climax—a wild and rather mad climax—that process of English self-love in which we have looked at nature and found many of our most cherished values reflected there.

In eighteenth-century England the artist who more than any other held up that mirror to nature was Stubbs. In the nineteenth century it was Landseer. So, what about the twentieth? Our century. For a start, the mirror shows us remarkably few animals. We have to advance to the middle years of the century before art once again begins to offer us images of animals who are stand-ins for human nature; and then it is mostly in sculpture, during that rather uncertain period in English art when sculptors in the wake of Henry Moore and Picasso began to invent creatures unknown to science in order to convey disturbing thoughts about human nature in the era of the nuclear bomb, sculptors like Lynn Chadwick, Kenneth Armitage, Michael Ayrton, Elisabeth Frink.

I can think of any number of books about animals as human beings in the twentieth

century, from *The Wind in the Willows* to *Animal Farm* to *Watership Down*, but of paintings very few indeed. Maybe Landseer killed them all off.

What also has to be taken into account is that until the end of the Victorian era much of English art reflected the outlook and interests of the feudal classes. Both Stubbs and Landseer expressed a view of man and nature held by the landed aristocracy. But by the present century this class of Englishman had really ceased to patronize art, or to exert any influence on it.

This means that artists on the whole ceased to offer a consensus view of man's relationship to nature. It was no longer a matter of describing a collective experience. Instead, it became a personal one. The new patrons were united only by their interest in 'modern art': they had no shared vision of England which they expected paintings to reflect.

Accordingly, the story of English twentieth-century art that is to do with nature is one of individual relationships. To a large extent it is the story of artists—or groups of artists—going off and living and working in particular parts of the country with which they have felt in special harmony—Suffolk, Cumbria, Pembrokeshire, St Ives among them. The result has been a sequence of intense personal visions. Mostly these have displayed landscape as something external to man—as nature observed. But now and again there have been visions of nature as a kind of human force—a hypnotic force holding man in its grip as though he was a part of nature and was reflected in all of it.

There are two English artists of the twentieth century who took this total identification of man with nature about as far as it is possible to imagine, one a painter and the other a sculptor: Graham Sutherland and Barbara Hepworth. In outlook, style and artistic personality the two have nothing in common: they are merely the same generation, both born in 1903. Yet they share this experience of a personal rapport with their natural surroundings in which nature becomes a truthful echo of mankind and a store of metaphors of the human condition.

It is a way of experiencing nature that is expressed with intensity in the poetry of another contemporary of Sutherland and Hepworth, T.S. Eliot. One of Graham Sutherland's best-known canvases, now in the Tate Gallery, is called *Entrance to a Lane*, painted in 1939 (Plate 25). And when I look at it a passage of Eliot always comes into my mind. It is from *The Four Quartets*, and it was written at more or less the same time as Sutherland painted his canvas.

> In my beginning is my end. Now the light falls
> Across the open field, leaving the deep lane
> Shuttered with branches, dark in the afternoon,
> Where you lean against a bank while a van passes,
> And the deep lane insists on the direction
> Into the village, in the electric heat
> Hypnotised. In the warm haze the sultry light
> Is absorbed, not refracted, by grey stone.
> The dahlias sleep in the empty silence.
> Wait for the early owl.

OPPOSITE
25 Graham
Sutherland, *Entrance
to a Lane*. Oil. 1939.
London, Tate Gallery.

Fragmentary experiences of nature, like jigsaw pieces, are fitted together into a pattern until the sense of a human presence emerges in the landscape.

With Stubbs and Landseer the reflection in nature is always self-admiring. But with Sutherland it is the reverse. Man looks at nature and the image it throws back at him is threatening and fearful. Nature no longer offers man reassurance and serenity. In Sutherland's paintings the fine upstanding oak-trees of George Stubbs are falling down like diseased giants. Instead of an ageless canopy of summer branches, there are exposed tree roots, spiky and menacing. Branches sprout warts, are bent and twisted. Nothing is fecund. There is a pessimism and claustrophobia about this vision. Man cannot get out of it because it is all a part of him. Nature's condition is his own condition.

And the creatures who inhabit this dark planet—our cousins? ourselves?—are mutants. They are the progeny of diseased cells, survivors of some nuclear holocaust, who peck and bite, are cold and heavily armed with claws and horns, or held snarling in chains in dank prisons. Held by whom? By each other? Are we the jailors or the jailed? We do not know.

Typically, the tree that appeals to Sutherland most strongly is the thorn-bush: nature's barbed-wire. An invitation to impalement. More than this, the thorn-bush recalls nature's ultimate symbol of man's suffering, the crown of thorns (Plate 26). It takes on the form of a cross; it becomes an image of the Crucifixion itself. Nature, the mirror of man's evil, becomes the instrument for torturing man's god. A bleak, bleak vision. Sutherland looks at nature through a glass darkly. He never stands back to admire: he peers into the undergrowth and sees nasty things lurking there. What he sees is mankind crippled, predatory, struggling feebly. Anything but noble, like Stubbs. Anything but heroic, like Landseer.

Barbara Hepworth was quite different. It is fitting that her memorial should be her garden—the sculpture garden in Cornwall where she would often work within the sound of the sea and the sight of the hills. All her sculpture is a celebration of the human spirit, and her expression of this spirit was most often through the imagery and materials of landscape—carved wood and stone, the shape of hills, trees, rocks, sea-caves.

In her Introduction to the book *Drawings from a Sculptor's Landscape* she said, in 1966, 'I cannot write anything about landscape without writing about the human figure and the human spirit inhabiting the landscape. For me, the whole art of sculpture is a fusion of these two elements—the balance of sensation and evocation of man in this universe.'

Barbara Hepworth chose to live in a part of England that is dominated by rock. As a carver she came to feel a strong affinity between the process of making sculpture and the way rocks are carved and heaved about by natural forces. It was as though nature around her awakened her to herself. In the same Introduction she wrote that 'All sensitivity to landscape is in one's ability to feel within one's body.' And in her *Pictorial Autobiography*, 1969, the identification with nature is even closer: 'I, the sculptor, am the landscape.'

Here is a bond with landscape so physical it is like an umbilical cord. Landscape as the Earth Mother. This may sound far-fetched, but Barbara Hepworth hit on an experience which many of us have probably had without necessarily stopping to think about it, which is

OPPOSITE
Graham Sutherland, *Blasted Oak*. Pen and wash. 1941. Private Collection.

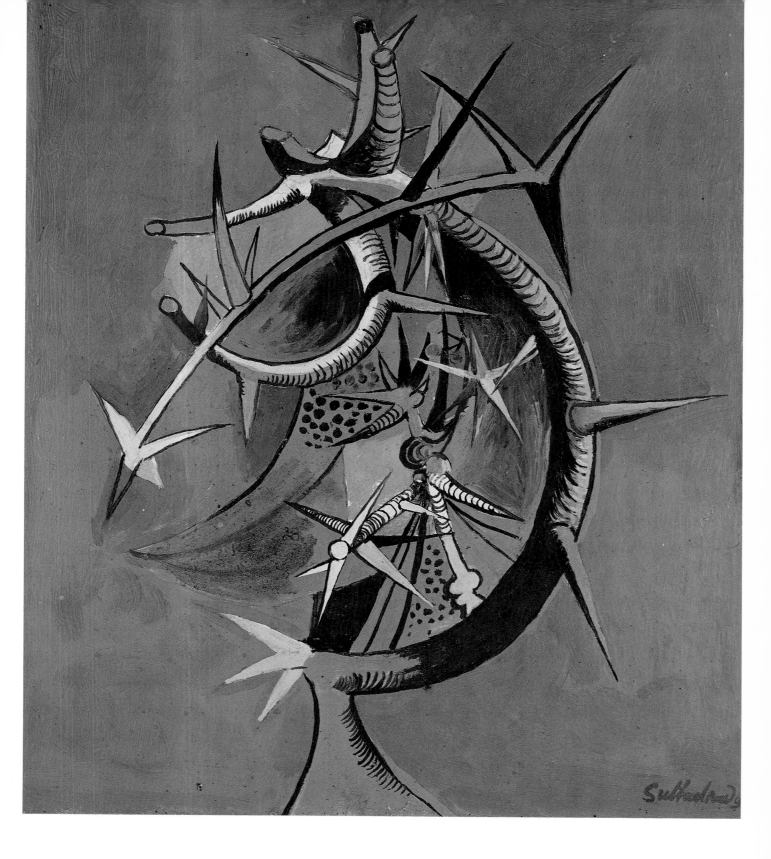

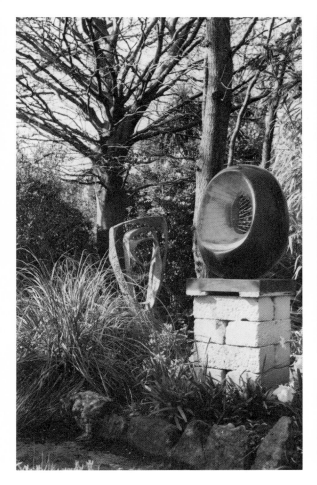

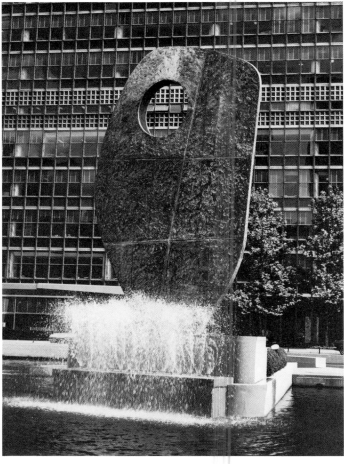

ABOVE
Barbara Hepworth,
Trewyn Studio Garden,
St Ives, Cornwall,
April 1970:
Garden Sculpture (1958)
and *Spring* (1966).

ABOVE RIGHT
Barbara Hepworth,
Single Form. Bronze.
1963. New York.

that certain forms in landscape arouse physical sensations when we look at them—or, even more, when we come into contact with them. For instance, a great boulder lying flat is just a boulder. Part of the land mass. A sort of natural table. But imagine it tipped up and it acquires a presence: it becomes like a human figure. We no longer step on it, we touch it with our hands; we may even place our arms round it.

And if that upright boulder widens out from the base upwards, it is not simply a figure, it is a figure that is rising, standing on tiptoe like a dancer. Barbara Hepworth herself practised ballet in her student days, and in London she would go along to Diaghilev's Russian Ballet and get herself invited behind the scenes to watch the dancers limbering up. The experience and the image of figures raised up in dance remained for her a symbol of human aspiration, and this same association of form and spirit became transferred to images of landscape: 'I would imagine stone images rising out of the ground, which would pinpoint the spiritual triumph of man.' When in 1963 the United Nations Secretary-General, U Thant, invited her to make a large sculpture to stand in front of the UN building in New York, this was the shape she chose. Reticently, she called it just *Single Form*.

Basically here is a landscape form—but raised upright and narrowing at the base so that it arouses a variety of associations: it is a torso, a dancing figure, a profile with an eye surveying the world, an expanse of space in which the sun rises, a human hand raised in greeting or allegiance. All these are put together in this very simple totem to express the hopes of mankind for peace and justice.

She once said to me in the sanctuary that was her garden:

My sculpture has often seemed to me like offering a prayer at moments of great unhappiness. When there has been a threat to life—like the atomic bomb dropped on Hiroshima, or now the menace of pollution— my reaction has been to swallow despair, to make something that rises up, something that will win. In another age, a more peaceful age, I would simply have carved cathedrals.

Virtually all sculptors before Barbara Hepworth had been men. It was not considered a ladylike thing to do. She put an end to that. And in doing so she brought to sculpture something it had never possessed before—a sense of what it felt like to be a woman: to be physically frailer than half the human race; not to be proud of muscles like Michelangelo, or feel yourself to be God, like Rodin. But to be vulnerable. Also to be profoundly conscious, in a way that a man is not, of the body's interior—having a vagina, a womb, menstruating, bearing children.

Typically, the way she expressed this sense of being a woman was in terms of nature. The idea that a body has its own interior landscape. So, carving a figure in wood means revealing its grain to show how a tree grows from within. Carving stone hollows it like a sea-cave. Suddenly all those experiences we have had since childhood of watching the tides, the patterns of light on the rocks, and the breaking of buds in spring, are given back to us as sensations relating to the human body—as though we ourselves are invited to become the landscape as we look at these carvings.

Perhaps it is no coincidence that the ultimate human identification with nature should be through the imagination of a woman. In the English language, after all, nature *is* female. We talk about Mother Nature, Mother Earth, the Motherland. Works of art show us that men have owned nature, controlled nature, projected themselves on to nature, but have never identified with nature in their very guts in the way that Barbara Hepworth did.

NATURE IN
FLOWER

Ever since Classical Greece there has been a tradition that the Truth residing in the world lay in its Beauty. The Greek view was that this was most perfectly expressed in the young male body: hence the cult of the athlete in Greek life and Greek art. Then, with the spread of Christianity, the male body had to be relieved of its aura of perfect beauty because of its inescapable associations with Adam, the Fall of Man and carnal sin. Instead, the search for Truth and Beauty shifted to the environment of man that had remained untainted by sin and disobedience: in other words, God's perfect creation—Nature. Truth and Beauty resided in the Garden of Eden.

The Protestant Church, with its emphasis on the supreme value of the Bible as a primer of faith, fanned this affection for the natural world as something that was pure and perfect. The search for Truth in nature focused on what could be considered to be the most beautiful creation of nature. And in England the most popular candidate has been the wild flower. Over and over again English art and English poetry have put across the view that if you wanted to know what the Garden of Eden was like, then you got down on your hands and knees and looked at flowers—the smaller the flowers the better.

William Wordsworth wrote two poems about the common daisy—not, admittedly, very inspiring poems—and two more about the Lesser Celandine, treating it as though it was the Star of Bethlehem pointing the way to Christ. And William Blake wrote: 'To see a world in a grain of sand / And a heaven in a wild flower.' What very English sentiments these are! The idea that flowers bring a touch of heaven to the landscape is, I would think, one of the most widely held and deeply felt beliefs there are.

Not surprisingly, as the loveliest adornment of nature, flowers have been made the loveliest adornment of just about everything we have valued. It is not simply that we are a nation of gardeners and a nation of plant-lovers. Love of flowers, and the spiritual value attached to them, is deeply rooted in just about every aspect of our lives. Our language, for example. When we are happy we blossom. A successful enterprise is said to be blooming. A romance that is working out well is flowering. A beautiful woman is as fair as a rose. And so on. Flowers award a stamp of value to what we do and to what we cherish.

The very names we have given to flowers speak of our profoundest affection for them. Woven together they make some of the richest vernacular poetry in our language. Traveller's Joy. Snowdrop. Snapdragon. Pimpernel. Shepherd's Purse. Buttercup. Sweet William. Lily of the Valley. Foxglove. Larkspur. Honeysuckle. Meadowsweet. Periwinkle. Pennycress. Jack-go-to-bed-at-noon. Columbine. Star of Bethlehem.

What a range of experiences is compressed in that list. They are names that have drawn around themselves, as the flowers themselves have done, veils of folk-lore and meaning. An entire culture of rural life lies in these names: they speak of a human intimacy with nature, a way of life in which a web of countless associations binds people and countryside in harmony. Even when those associations are ugly the poetry is still present. Adderstongue. Viper's Bugloss. Dragon's teeth. Stinking Hellebore. Fleabane.

As flowers adorn language, so they adorn our sentiments and the places to which

OPPOSITE **27**
George Gower, *Mary Cornwallis*. Oil. c.1575–80. Manchester City Art Gallery.

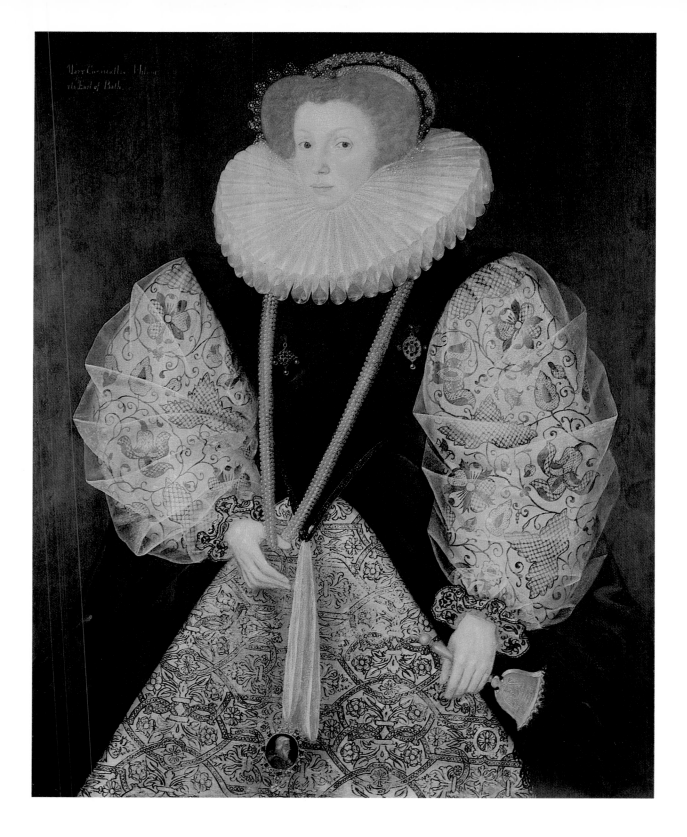

Honeysuckle

Viper's Bugloss

our sentiments most deeply attach themselves. If we want to make a house prettier and more loved, then we train flowers over it and plant flowers around it. One of the many unlovable aspects of tower-blocks is the distance imposed from anything that grows. Even the tiniest backyard may have a tub with nasturtiums trailing from it and a buddleia that has crammed itself into the chink of a wall, glimpsing the sun just long enough to attract a butterfly.

Inside our houses, too, flowers are everywhere. It is as though we had invited nature in. We have flowers in vases, on the wallpaper, the curtains, the upholstery, the carpets, the vases, and on the things we eat from, the things we drink from—plates, cups, saucers, dishes, bowls, even glasses. If we want to celebrate in style, what do we drink? Champagne! And what do we drink it out of? As likely as not, a tulip glass. The shape of a flower, the most perfect creation of nature, becomes the most appropriate vessel for one of the most perfect creations of man.

Nowadays drinking glasses may be of less worth than the wine. Smash a few and you go out to the hardware shop and buy another dozen in a box. But if you go back two hundred and fifty years, this was not so. The glass was just as precious as the wine, and quite possibly more so. Visit one of our leading museums, like the Victoria and Albert Museum in London, and take a look at English eighteenth-century drinking glasses. They are among the most beautiful functional objects ever made, especially those tall, slender glasses with a twist-pattern that whirls up the stem like some perfectly controlled vapour-trail, and a bowl that continues the line of the stem but broadens out just sufficiently to hold the wine.

Not only do these slim drinking glasses rise into the form of a flower, but the glass flower you drink from is itself engraved with the delicate ghost of yet more flowers. The glass-maker honours a fine wine with the shape and image of something equally perfect. It is his homage to nature: though in a sense it is also his bid to outdo nature. Real flowers, after all, fade and die. But unless you break it a fine drinking glass will last for ever.

Flowers grew—as it seemed—in the crystalline medium of glass. By the end of the nineteenth century, technological sleight of hand had grown so deft that the challenge of actually copying flowers was answered by English glass-makers in the form of sinewy (and quite unusable) tulip shapes in multi-colours with slender trailing leaves—all echoing the prevailing international fashion for *art nouveau*, and endeavouring to look as though they had come straight out of the Victorian flower-bed.

In that wonderful Granny's Attic which is the Victoria and Albert Museum, as you meander from English room to English room it can feel like stumbling from flower-bed to flower-bed—flowers decorate everything: glass, pottery, porcelain, costume, tapestry, silver.

Flowers have also adorned *us*, the things we wear. Some of the most sumptuous examples of this survive in paintings. Tudor portraits are not the most animated works of art in our heritage: compared to the plays and poetry of the era they seem bloodless. The faces of kings and queens, and their courtiers, have a waxworks look as if the sitters had sat for the artist far too long—or perhaps not at all.

What catches the eye is not their waxworks faces but the clothes they wear.

There is a stern painting in the National Portrait Gallery of the unlovable Mary Tudor in about 1554, just after she had succeeded to the throne. Apart from the wealth of jewellery on her neck and bosom the most distinctive feature of the painting is her open collar, which is embroidered in black silk on linen. This is an example of what is among the earliest kind of domestic embroidery known in England, 'blackwork', and the characteristic of Tudor blackwork is the motif of the flower. You might imagine that a queen would wear something exotic, but the Queen of England—like Wordsworth—was happy to celebrate the common daisy.

One of my favourite Tudor portraits hangs in the Walker Art Gallery, Liverpool, attributed to Nicholas Hilliard. It is of Mary's successor, Queen Elizabeth I. The white pasty face gazes out under a fuzz of red hair, and she is wearing an amazing red robe encrusted with jewels. Underneath the robe, covering her neck and arms, is a blackwork smock embroidered again with flowers. This time they are roses—Tudor roses, a heraldic device signifying the union of the houses of York and Lancaster. What is revealing is how the English embroiderer has turned a rose that never was into a real rose, with leaves and buds and branches. Nature has taken over again.

The Elizabethan court was steeped in nostalgia for a medieval world of chivalry and Gothic decoration. A land of dreams and 'courtesie'. And these portraits remind me of that most elegant of the medieval arts—those miraculous tapestries in which figures wander through life as if through a daydream of love, treading carpets of tiny flowers. *Millefleurs*, the French called them: tapestries of a thousand flowers, pin-pointed like a thousand brilliant stars across the floor of heaven.

Look at Tudor costumes and you see that carpet of heaven stitched up into sleeves and collars, smocks and bodices, and the figures within them retreat into the anonymity of a dream. Occasionally they surprise you with a gesture—like Mary Cornwallis, Countess of Bath, whom George Gower painted in the 1570s, drawing our attention to her pearls by hooking them round her thumb (Plate 27). She makes no other movement of muscle or eye: she gazes blankly at us from the walls of the Manchester Art Gallery. But with this little crook of the thumb she says, 'Look at my pearls of great price!' And as we do so we look too at the arms that support that small gesture. Under a froth of gauze her sleeves are embroidered with vines, lilies and roses gloriously patterned in black on white. The splendour of nature matches the splendour of her pearls.

Because they are perfect, because they are pure, flowers confer a blessing on all manner of things we value, conveying sentiments for which there are sometimes no adequate words. In times of love, in times of grief, we say it with flowers because this seems the most natural, the most direct, way to say it. There are flowers for a bride and flowers for a grave. And there are flowers that say 'Welcome!': the municipal authorities of Torquay and Weston-super-Mare do not stand on railway stations waiting to greet every holiday-maker, but they do ensure that an ingenious floral display in the form of a clock or a heraldic crest issues its greeting along the promenade.

Foxglove

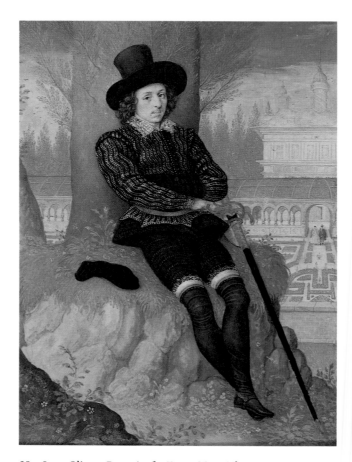

28 Isaac Oliver, *Portrait of a Young Man*. Oil. Miniature. Late
sixteenth/early seventeenth century. Windsor Castle, Royal
Collection.

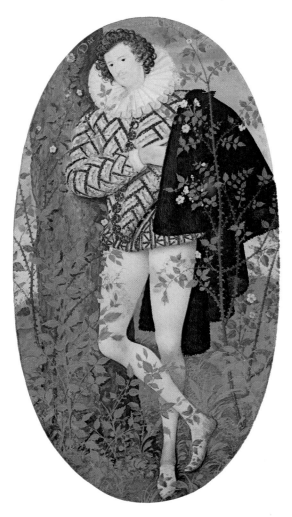

29 Nicholas Hilliard, *Unknown Man Among Roses*.
Oil. Miniature. *c.*1588. London, Victoria and Albert
Museum.

A group of eighteenth-
century drinking-
glasses engraved with
flowers. London, Beet
and Hayhurst.

Silver tankard. 1657. London, Victoria and
Albert Museum.

But of all the sentiments that flowers carry, there is one above all others—a man's love for a woman. Flowers are a male language to use about women.

> There is a garden in her face,
> Where roses and white lilies blow;
> A heavenly paradise is that place,
> Wherein all pleasant fruits do flow.

The sentiments of the Elizabethan poet Thomas Campion echo those of any number of Shakespeare's lovers, and of any number of young men who were painted by Elizabethan miniaturists so that their portraits might be carried by the ones they loved.

Nicholas Hilliard painted what must be the best-known of all Elizabethan miniatures, now in the Victoria and Albert Museum (Plate 29). It is of an unknown young man

Seventeenth-century embroidered panel with floral motifs. London, Victoria and Albert Museum.

showing off his fine legs and fine feelings to . . . we are not told whom. But Campion's verses could have been in his mind. He leans nonchalantly against a tree, one leg crossed over the other: his right hand rests on his heart, his cape dangles over one shoulder. He is announcing that he is in love, and the most natural place for a man in his state of mind is alone in the open air entangled with the emblem of his passions. His love for whoever it is has filled the painting with roses. They are growing all over him. The roses are wild, deliciously scented, and armed with thorns. With the aid of nature, the picture says it all.

The Elizabethans' feeling for flowers, and the sentiments they carry, is never far from their paintings and their poetry. Hilliard's finest pupil, Isaac Oliver, painted a number of languid aristocrats taking time off from the business of state to consort with nature. One of these—now in the Royal Collection—is a young knight with a sword who is displayed in front of his splendid palace and his perfectly manicured formal garden (Plate 28). Yet he chooses to seat himself casually upon a bank of flowers and lean against a tree. Again the sentiments find echoes in poetry, this time Shakespeare:

> I know a bank where the wild thyme blows,
> Where oxlips and the nodding violet grows,
> Quite over-canopied with luscious woodbine,
> With sweet musk-roses, and with eglantine.

Then the mood of flowers dissolves. With the rise of Puritanism, and the Civil War, English painting now shows men setting about being men. The impact of Rubens and Van Dyck helped shift the emphasis from the inner man to the man of action. There was no time for love and roses while kingdoms were being lost and won. And when the Restoration of Charles II brought with it a reaction against Cromwell's Puritanism, the new hedonism ushered in a form of art (typified by the portraiture of Sir Peter Lely) that has little to do with love as the Elizabethans had understood it. Now it is women who lie about on banks where the wild thyme blows, waiting for . . . no, not love, but sex. The art of the Restoration is about flesh, and men lusting over it, none more so of course than the King himself, who preferred his appetites whetted by portraits of Nell Gwyn baring her breast than by the symbolism of wild flowers.

In the eighteenth century sentiments of love creep back into English painting, and flowers begin to find their place again. But it is no longer the medieval nostalgia of the Tudors, with dreams of sentiments laid across a carpet of wild flowers. The tone is now demure, sophisticated, and rather French. Flowers are offered in polite bouquets. Among the most touching eighteenth-century love portraits we have is one by the Scottish painter Allan Ramsay of his young second wife, now in the National Gallery of Scotland. He has placed a rose in her hand and a bowl of them by her side. He has said it with flowers and she has said it with a look.

But it was really the nineteenth century that opened up to artists just what powerful emotions flowers could bear. This was the time when gardens all over Britain were becoming *flower* gardens, with roses everywhere, flower-beds, herbaceous borders. Bare earth in the winter, a riot of colour in the summer, and an immense amount of hard labour in between

30 John Martin,
The Plains of Heaven
(detail). Oil. 1853.
London, Tate Gallery.

the two. The Victorians invented the back-garden dream of floral paradise where you could wander and snip and feel at home in an orgy of cultivation.

Books on gardening suggest a number of reasons for this Victorian cult of flowers. Chief credit is frequently given to the garden designer Humphrey Repton, high-priest of the nineteenth-century Temple of Flora. Repton preached that gardens should be 'picturesque', like a picture or, in effect, like a pretty picture, this being the era of pretty pictures. Certainly they were not to be viewed as part of the landscape as Capability Brown had urged in the eighteenth century. And certainly they were not natural. The garden, wrote Repton, 'is an artificial object, and has no other pretence to be natural, than what it derives from the growth of the plants which adorn it; their selection, their disposition, their culture, must all be the work of art.'

Repton took the designing of the English garden away from architects, poets and students of Old Master paintings, whose influence had hitherto been uppermost, and he gave it to gardeners. Now what mattered were the plants—growing them, displaying them, massing them for effect. And never had there been a time when plants were more abundantly available. British trade, communications, exploration and empire-building rose to their zenith in the nineteenth century, and plants from the far regions of the globe were brought back in quantity by British merchant-ships, gathered from China and the Himalayas, India, Africa, South America, the West Indies, anywhere in fact where traders and explorers set foot. The English garden became transformed into a plant emporium upon which the sun never set.

Flowers also had a profound impact upon the nineteenth-century imagination, and in order to detect what this might be it is revealing to turn from gardens to painting, because what nineteenth-century English artists managed to do was to unveil some of the fantasies that swarmed in the minds of those who were transforming their private acres into a floral paradise.

Early in the Victorian era there was a painter of erratic fame who, it has often been said, ought really to have lived a hundred years later and taken his talents to Hollywood in the service of Cecil B. De Mille. He was John Martin, sometimes referred to as 'Mad' Martin. His imagination was bred out of the wilder visions of Turner. Turmoils of rock and sea announce apocalyptic events.

Towards the end of his life Martin painted three huge 'Judgement' pictures, as he called them, the most famous of which is *The Great Day of His Wrath*, now in the Tate Gallery. Less known, because it has remained in private hands, is a vast landscape entitled *The Plains of Heaven* (Plate 30). It is a rendering of that vision of paradise experienced by the apostle John on the Greek island of Patmos, and which has come down to us in the Book of Revelation. 'And I saw a new heaven and a new earth; for the first heaven and the first earth were passed away. . . .'

When you gaze at Martin's rendering of St John's vision it is clear that paradise for him was composed of two things. At first sight it is a travel poster. Then, on closer scrutiny, it is a place that blossoms with beautiful women. The plains of heaven are carpeted with summer flowers like the most luscious Victorian herbaceous border; and wafting about the flowers are quantities of maidens in a froth of virgin white, dancing or playing heavenly harps, their long hair glistening in the sunlight.

The association owes nothing to St John, needless to say. It is entirely Martin's. Here is a typical Victorian male fantasy—part-sugar, part-lust. In heaven there can only be purity and perfection: flowers are pure and perfect, and so are beautiful maidens. They are like flowers. But flowers are also there to be picked. The bewhiskered bankers who flocked to admire this painting on the triumphant tour it made round England and America during the 1850s and 1860s would hardly have missed the double significance of Martin's comparison. They would have felt publicly cleansed and privately roused.

In Victorian painting flowers invariably tell a story, and it is usually the same one. They advertise purity and they suggest lust. More than thirty years after Martin's vision of a nubile herbaceous border an artist called Marcus Stone painted one of those moody pictures

Peter Lely, *Nymphs by a Fountain*. Oil. 1650–60. London, Dulwich Picture Gallery.

31 John Everett Millais, *Ophelia*. Oil. 1851. London, Tate Gallery.

32 Marcus Stone, *In Love*. Oil. 1888. Nottingham, Castle Museum.

about domestic relationships of which the Victorians were so fond. He called it *In Love* (Plate 32). And that is what is supposed to be conveyed by the flowers in the summer garden where the couple sit, and by the bunch of flowers which lie at the girl's side as she does her sewing.

But look again. The young couple have only one thought on their minds, and it is not the purity of love. They are separated by a great distance, and between them floats an agony of sexual desire. This is the tension surrounding the two figures, and this is what the flowers actually draw our attention to. For the benefit of more obtuse visitors to the Royal Academy Summer Exhibition of 1888 Stone emphasized the point by setting his lovers beneath a tree whose forbidden fruit lies uneaten on the table. He restrained himself from adding a serpent.

Even the sweetest of Victorian pictures can convey this ambiguity of sexual meaning through the imagery of flowers. Augustus Mulready, a contemporary of Marcus Stone, enjoyed painting the then-fashionable theme of poverty, and one of his most fetching pictures is of a London flower-girl.

Standing in the light of a street-lamp she looks as sweet as the roses she sells. She carries a basket of flowers in one hand and holds out a posy in the other. Her eyes are raised towards some rich passer-by. Anyone looking at the picture must have assumed it to be a man: no lady would have been out walking alone on the London Embankment at night. But what does he actually want to buy? The roses or her? By the very sweetness of the girl the picture invites the question.

This kind of subliminal suggestion is the very fabric of much Victorian painting. Flowers are pure. Flowers are to be picked. The Victorians worshipped innocence, and they ached to spoil it. In their paintings flowers tend to confer on women the most desirable kind of unavailability. And in this way flowers can make tragedy sweet, even death something exquisite. So, Millais's Ophelia drowns in a stream of wild roses as though it were a bed of love, and she were waiting to embrace her lover (Plate 31).

A fashionable Academician of the 1890s called J. W. Waterhouse painted the Greek myth of Hylas, who was lured to his death by water-nymphs, as a nude bathing romp in the water-lily pond by a group of teenage girls at a finishing-school being naughty with the gardener's boy. Not a hint of menace; only saccharined eroticism. The flowers they swim in confer purity on the girls as well as a promise of the sweetest delights (Plate 33).

By way of contrast, in those same final years of the nineteenth century the French artist Claude Monet was also painting water-lilies—in the garden he was creating at Giverny. Monet's obsession for his theme matched that of the Victorians. But what he painted—over and over again—were just flowers. Nature all by itself. Colour. Light. Reflections. Nothing to do with people at all. It is hard to imagine a vision of a garden less like that of the Victorians.

The flower-garden was the stage set for the Victorians to release their dreams, and it is their art that gives us a glimpse of what these dreams were. The Victorians were the masters of unspoken sexuality. Gardens were their paradise on earth. It is only from their paintings that you realize that in their imaginations every paradise has an Eve.

Then, quite suddenly, the vision fades. It is not that the flowers fade. The English garden remains a flower-garden. But when you look at twentieth-century art all that subliminal eroticism has vanished.

The modern movement in art hit England late. As long as Queen Victoria was alive it was as though the seas around Britain could still hold it out, but once she had died our defences at last weakened. And when the invasion came—Impressionism, Post-Impressionism, Fauvism, Cubism, all in a rush until the English art world reeled before these successive waves—the Victorian dream was shattered. All those erotic double meanings the nineteenth century loved so dearly simply disappeared. Flowers became just flowers again.

It does not really matter where you look. Cedric Morris painted gorgeous bouquets of flowers in vases. Ivon Hitchens painted them as points of colour in a room or in the landscape. Surrealists such as Paul Nash and John Armstrong painted flowers as strange receivers of nature's mysteries, but the mysteries lie out there, in the great unknown, not within us in the secret longings of the human libido. Even a rose tickling a woman's bosom, painted by an artist as sensuous as Matthew Smith, carries no special charge. Smith was far too interested in the colours and curves of the human body to concern himself with anything as whimsical as the psychology of flowers.

David Hockney's double portrait from the 1970s of two fashion designers, Mr and Mrs Ossie Clark, includes a vase of lilies just as elegant decor—no more significant than the lamp or the cat. Had he been a Victorian painter Hockney would have practically hit us over the head with madonna lilies and their message of the lady's purity.

So, did it all just go, that long English tradition of saying it with flowers? No, of course not! It simply went commercial. English artists had perfected the most potent erotic symbolism of flowers, and in the twentieth century advertising agencies gratefully took it over.

John Armstrong,
Dreaming Head.
Tempera. 1938.
London, Tate Gallery.

33 J. W. Waterhouse, *Hylas and the Nymphs*. Oil. 1896. City of Manchester Art Galleries.

OPPOSITE **34** George Watts, *Ellen Terry*. Oil. *c.*1864. London, National Portrait Gallery.

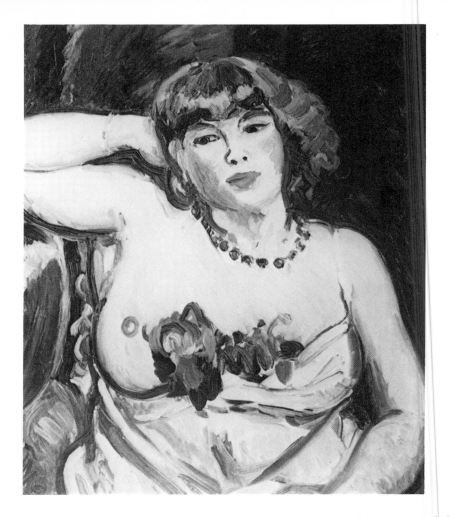

Matthew Smith, *Jeune Femme*. Oil. 1930. Cape Town, South African National Gallery, Natale Labia Collection.

Saying it with flowers became *selling* it with flowers, subliminal meanings and all.

Look around: at posters, magazines, television advertisements. It is all there. 'See me, Feel me, Hold me, Touch me'—four hands with bouquets of flowers are selling wool. The champagne blonde with the basket of flowers and the sweet-sixteen smile leads a white horse through the meadows, and sells shampoo. The soft-focus girl daydreaming in the mirror has plucked flower petals instead of hair, and sells perfume. Perfumes. Soaps. Deodorants. Beauty creams. Lipsticks. Bras. Boots. Tights. Jumpers. Chocolates. Mints. Spirits. Wines. The desk in front of me as I write on this grey winter afternoon is strewn with the petals of advertising: each is endorsing the purity of some product, and each is associated with a stunningly beautiful model who is everything a man might desire.

Advertising offers itself to us as art. It has to: art is its only vehicle. If it cannot enchant it cannot do anything. The difference between these advertisements and Victorian paintings is that the products are aimed at women, whereas Victorian art was aimed primarily at men. And yet the message to women remains exactly the same: if you want to be loved by a man, be his fantasy, be as perfect as a flower, step into the garden of his mind. And he will love you for ever.

In the dreamland of advertising flowers confer beauty, freshness, innocence . . . and tremendous desirability—on the model, and therefore on the product she sells (Plate 36). Let me pick out just one recent advertisement from the heap of cuttings on my desk. It is for the

The original French skin boots 12½ gns.

Elliott
Knightsbridge
Bond Street and Now
KINGS ROAD
CHELSEA

Pronuptia Bridal Collection—the 'o', incidentally, printed as a heart beneath two embracing love-birds (Plate 35).

 The legend runs: 'Pronuptia make fairytales come true with their spellbinding collection of wedding dresses for you and your flowergirls.' The bride is dark-haired and dark-eyed to set off the snow-whiteness of her dress. She holds a spray of madonna lilies. More white flowers are in her hair and more still embroidered into the lace of her gown. Sprays from the fields surround her, including (a small lapse) ivy, which traditionally in pictures is supposed to mean she will be clinging. A Victorian artist would have given thought to that. On the other hand, perhaps Pronuptia bridegrooms like them that way.

 Behind her is the church. It is waiting for her, and the dream of advertising has opened it up to nature. Flowers cascade from gothic arches; the altar candles shine through them. The blessing of God may be what this occasion is supposed to be about, but there can be no doubt in the mind of the onlooker that the real blessing here is that of nature. Be as perfect as a flower and he will love you for ever.

 Flowers are the language of Everyman: they have adorned what we love most and what we value most. Because our declarations of love, of affection, of respect, have invariably been more stumbling than the sentiments which provoke them, we need and have always needed flowers to say what we are too tongue-tied to explain any other way.

A Dunn-Meynell and Keefe poster for Elliott boots. 1967.

ABOVE **35** and OPPOSITE **36** An advertiser's view: flowers and fairytale gowns for the perfect bride.

NATURE AND THE
CHURCH

The early rumblings of the Industrial Revolution roused English nature poets to call upon the authority of God in defence of our countryside now perceived to be under threat. God had not previously been a figure of much serious concern to English poets of the eighteenth century—or to painters. But now he made a powerful reappearance as the shining champion of all things natural, all things that the new and abominated species of industrial man was setting out to plunder and transform. 'Nature is but a name for an effect, / Whose cause is God', wrote William Cowper, echoing the sentiments of St Augustine of Hippo, St Thomas Aquinas and many other fathers of the Christian Church. In the same poem, *The Task*, Cowper proclaimed God's allegiance to the natural world in more bluntly challenging tones: 'God made the country, and man made the town.'

The poet's sentiments were genuinely and widely held in England during the late eighteenth century, and were even more passionately voiced during the early decades of the nineteenth as the mood of Romanticism prevailed. John Keats was quite clear that a man was closer to God in the countryside than he was in the town:

> To one who has been long in city pent,
> 'Tis very sweet to look into the fair
> And open face of heaven—to breathe a prayer
> Full in the smile of the blue firmament.

It is hard to imagine that Cowper or Keats would have felt closer to God had they lived in the Brazilian jungle or the Sahara desert, or even in the Spanish sierras or the malarial swamps of the Rhone delta. It had to be a special kind of countryside for God to be honoured as its architect: soft and green and fertile—in other words, landscape that could be reasonably claimed to resemble the Garden of Eden before the Fall of Man. And English nature poets and landscape painters strongly supported the view that the closest you could get to such a paradise was in the countryside of England.

As so often with visions of rural England, it is Constable who supplies the most cherished images of English landscape as the landscape of God. The painting which is surely the most popular of all Constable's works makes the point perfectly—*Dedham Vale*, now in the National Gallery of Scotland in Edinburgh. It is Constable's definitive account of a favourite scene he had first painted twenty-six years earlier. It was the countryside of his childhood, the countryside of his deepest affections. He considered the painting to be 'perhaps my best'.

Trees and water and flat meadows are spread out under an enormous sky. The England Constable loves rolls away from the feet of the spectator to the horizon. And right in the middle of the painting, gathering it all together, Constable plants his church. The tall tower of Dedham church is like a post to which the entire landscape seems tethered. It commands the countryside of man, and grows out of it.

Even when he paints Salisbury Cathedral Constable carefully selects views that relate it to the country rather than to the city. He chooses to paint the cathedral from across the water meadows, framed by a rainbow; or from the bishop's grounds set within a garland of trees

OPPOSITE
John Constable,
Dedham Vale. Oil.
1828. Edinburgh,
National Gallery of
Scotland.

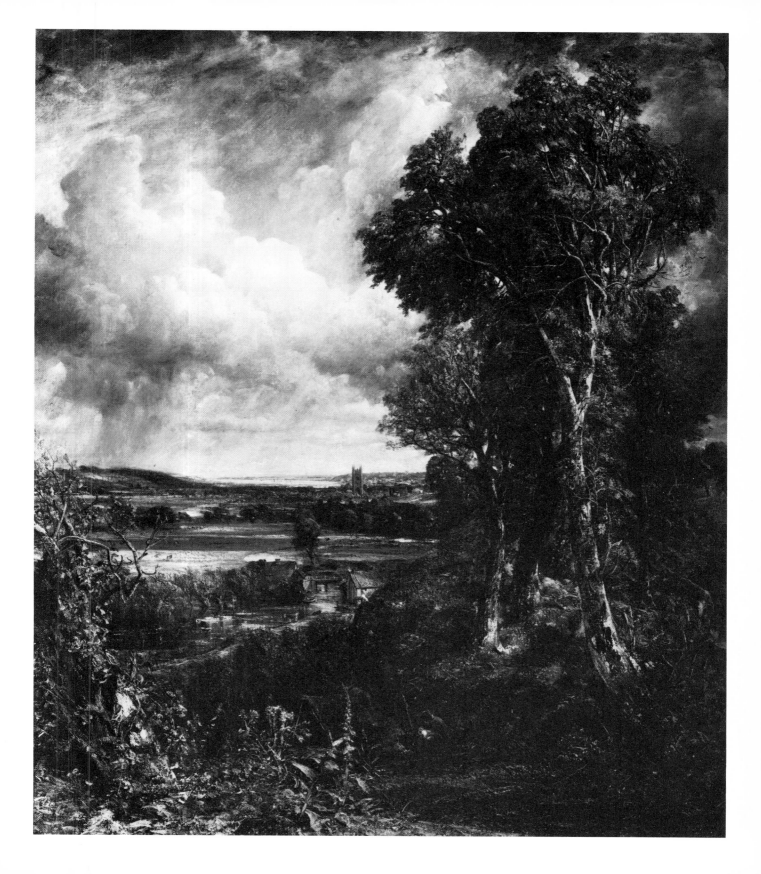

duplicata est omnis substantia ei' ac filii.
uidens bona omnib; dieb;.

EXPLICIVNT CAPITVLA.

INCIPIT LIBER IOB.

VIR ERAT INTER RAHVS NOMINE IOB;
Et erat vir

ille simplex et rectus ac timens devm.
& recedens a malo. Natiq; sunt ei septem
filii. & tres filie. Et fuit possessio ei septe
milia óuiú. & tria milia camelo4. qn

37 The initial V to the Book of Job in a twelfth-century Bible. Oxford, Bodleian Library.

38 The Lindisfarne Gospels: initial page from the Gospel according to St Matthew. *c.*700. London, British Library.

(Plate 39); or from the close where contented cows munch peacefully in the sunlight.

The gentleness of Constable's art masks the force of his vision, which is that the church is the link between nature and God. Nature is perceived as God's perfect creation: it is the paradise from which man was evicted. And by placing churches and cathedrals— hymns to God—in a setting of nature, he brings together a love of nature and a love of God. They are symbolically fused. The harmony in Constable's paintings between nature and church is therefore a kind of redemption.

Constable is not an explicitly religious painter like Samuel Palmer, yet he offers this religious meaning to a love of landscape, and it is one that has exerted the most profound influence on the way we have come to view our natural environment.

In earlier chapters I traced the stages by which nature gradually ceased to be regarded as an unruly and hostile force to be kept out, and instead became respected and admired, welcomed into man's estates and gardens, and a subject worthy of the artist's eye. Because Constable viewed nature as where man belongs and is most at home, he extended this love of landscape to embrace the dwellings and churches man erected in the landscape. Inevitably this is a vision of harmony which is dependent upon the view that all nature is beautiful and good. It is entirely appropriate to Constable who held that nature was 'simple, plain and true in all her works'.

On the other hand, it would have been a quite inappropriate vision in medieval England, when Constable's churches and cathedrals were actually being built. So, let me go back to the beginning. By looking at early English churches themselves, and at church art generally, a fundamentally different vision of the relationship between God, man and nature presents itself.

The early Church preached that men's vices derived from their animal instincts. In church art these vices are frequently represented symbolically in animal form (Plate 37). Beasts were the army of Satan. The earliest Christian vision of nature is of a hostile force with which to do battle: man against nature, which is really his own nature, hence the need for the Church to remind him on which side he should fight.

This dark view of the natural world coloured the art of Christian Europe for almost a millennium. The earliest Christian theologians had sought a philosophical framework on which to hang their faith, in particular the notions of good and evil which that faith proclaimed. Lacking any philosophical system of their own, they looked outside Christian thought and picked on Plato. Here was a mystic, a moralist, an other-worldly thinker whose mind was always anxious to fly towards the world to come: Plato was an ideal recruit to the Christian cause.

For Plato, everything that man could see and touch in the world consisted of Matter and Form. Matter was base and corruptible. Form was perfect and eternal. To early Christian theologians this philosophy was interpreted to mean that man himself was composed of a body, which was base and evil, and a spirit, which was eternal and perfect. Christian Platonists like St Augustine in the fourth century held that man straddled these two worlds—of body and of spirit. Man was the only natural creation of God to possess both a body and a soul.

He was therefore the only creation on earth capable of turning away from bodily things and seeking God through the soul.

Here was the theological base for thousands of medieval illuminated psalters, bestiaries, prayer-books, bibles, as well as carved ivories, alabasters, church portals and altar-pieces in which beasts without the blessing of a soul embody all that the good Christian strives to turn from in his own make-up.

But there is another tradition intermingled in early English church art, one that has no such flesh-hating theological base, and it derives from the pre-Christian art of Northern Europe, in particular that of Germany and Scandinavia. This is the tradition of employing the imagery of the natural world—especially its more wondrous beasts—for the purpose of elaborate pattern-making.

The highly wrought decorated pages of the seventh-century Lindisfarne Gospels, now in the British Library, are among the most vibrant examples of this tradition to survive in this country (Plate 38). As with the Winchester bibles five centuries later, it was the opening initials that gave play to the imagination of the artist, in this case Eadfrith, Bishop of the Northumbrian island of Lindisfarne.

The most striking of these decorated pages are those that begin the gospels them-selves: Matthew, Mark, Luke and John. The first letters of all four gospels resemble zoomorphic jewellery that has been spun in gold wire. Each letter breeds a jungle of living forms, writhing and interlacing like a snake-pit. Each stroke of the pen gives birth to a new creature of the mind.

They are fearsome fantasies but they are not intrinsically evil. They are not Satan. Indeed, it is inconceivable that pious monks in an outpost of early Christianity should have

39 John Constable, *Salisbury Cathedral from the Bishop's Grounds*. Oil. 1823. London, Victoria and Albert Museum.

introduced the gospels with images of the Devil. Whatever the precise meaning of these creatures in their pagan origins, here they suggest embodiments of wild nature that have been placed within the control of man and therefore tamed, their sacs of poison as it were removed by the alchemy of art, their fearsomeness transformed into awesome splendour.

In the art of the early Church the idea of nature held these two meanings, one derived from a distortion of Plato, the other from Germanic and Scandinavian nature worship. Neither was in origin Christian, yet Christian artists made the most wonderful use of both. Often they used them together.

The little twelfth-century parish church of Kilpeck, in Herefordshire, is one of those out-of-the-way places which sooner or later everyone who loves English churches makes a special point of visiting. It was built by the grandson of a Norman knight who came to England with William the Conqueror. And, like so many small Norman churches, architecturally it is not much more than a stone box. The glory of Kilpeck is its carving. Nature crawls all over it: dragons, entwined beasts, grimacing monsters all eyes and fangs, creatures with beaks, devouring jaws, bulging eyes. Nature is horrible because—in the official Church view—human nature *is* horrible. And it is carved in all its nastiness on the outside of the church as if to ward off the evil eye, and of course to be a terrible warning to all who entered. Deny the flesh!

Here is the killjoy vision of the Christian Platonists. The body is evil, the spirit is perfect. But this is not the only vision Kilpeck embodies. Coiling up the columns on either side of the south door are elaborately interlacing creatures which remind you of the figures that introduced the gospels of Lindisfarne. These have not been conceived as emblems of evil; they are accounts of nature that has been tamed by man, taught to perform brilliant tricks of contortion; they are nature re-created by the genius of art into objects for man's delight. Here is the other tradition breaking through.

They are twin visions of the natural world—the light and the dark. And it is in the mixing of the two that church carving of the Norman era achieves such a poignant balance of mood: pessimism and ecstasy, dread and laughter, denial of the flesh and celebration of the flesh.

In the thirteenth century this changes. The transformation from Norman (or Romanesque) to Early English Gothic is a profound one: it is more than an imaginative leap in technology fired by the discovery of the pointed arch and the rib vault. Writhing beasts vanish from church portals and arches, and in their place appear leaves, branches, flowers, fruit. Here is a fresh delight in nature. Churches themselves rise into the light like slender branches.

Early Gothic architecture embodies a number of revaluations which were taking place in the minds of medieval theologians, and in particular a revaluation of man's moral relationship with the natural world. In the early medieval world there had been little room for nature as a source of inspiration, because it was body and not spirit. According to the teachings of St Augustine even light, the light of the sun, possessed spiritual meaning only as a metaphor for divine illumination that guided man to the truth through its action on the mind. The experience was a mystic one, an interior one. Norman churches kept the light of nature out.

But by the thirteenth century the concept of light has become altogether more

significant. In the early decades of the century one of the most interesting theologians in England was a scholar by the name of Robert Grosseteste, Chancellor of Oxford University. His contribution to medieval thought might have remained a rather small footnote in the history of philosophy if it had had no bearing on English church art and architecture of the period.

For Grosseteste, the concept of illumination which he inherited from St Augustine was the very core of his thinking. He proposed that light was the superior element in all things; it was not simply radiated by God into the human mind. Light was what everything, from the smallest to the greatest, was composed of, and the amount of light in the composition of an object determined its spiritual value. At the lowest end of the scale was darkness, possessing no spiritual value at all, hence its association with evil, with Satan. And at the opposite end, pure light was God.

The relevance of this scale of values to the spiritual meaning of Gothic architecture is obviously profound; and it is especially so when you consider that Grosseteste's views on light coincided in time with some of the greatest achievements in Early English cathedral building— Lincoln, Wells, York, Ripon and Salisbury among them—all of them monuments to the spirituality of light. The admission of light into English churches bears witness to the admission of nature, and the revaluation of nature (Plate 41).

From the standpoint of technology the cross-ribbed vaulting of Early English

Capitals decorated with foliage, fruit and flowers at Southwell Cathedral, Nottinghamshire. Late thirteenth century.

cathedrals was an ingenious device for spreading the weight of a roof by distributing it on to piers widely spaced apart. But it also enabled the roof to be flooded with daylight by means of high windows that could be set between the vaults, so that visually the roof could appear weightless. It could seem almost to float on air—on light itself.

By the end of the century English cathedrals are not only welcoming light, they are also welcoming nature in from the hedgerows and the fields. The foliated capitals at Lincoln, Lichfield and—above all—Southwell are the stonemasons' homage to nature in honour of God. You only have to look at them to see that these leaves, flowers and fruit are not copied from some illuminated manuscript: they are copied from life, and after seven hundred years life still seems to breathe from them.

Southwell in Nottinghamshire is, I should imagine, the least known of all the ancient cathedrals of England. It has only been elevated to the status of cathedral for the last hundred years: before that it was a collegiate church within the archbishopric of York. The bulk of it is Norman—stocky, rather severe and slab-sided from the outside; handsome none the less, and constructed out of a local limestone which is among the most enduring building material in England.

It is this fine-grained limestone which provided the ideal material for the stone-masons of Southwell when they came to add their chapter-house in the Gothic style. They not only vaulted it with a star, they decorated it with images of foliage and flowers all around the entrance from the vestibule, and around the thirty-six stalls where the priests would sit. There was a sprig from the fields for each of them: hawthorn, oak, buttercup, potentilla, bryony, hops and—in quantity—grapes.

Clearly, this flood of nature imagery into English Gothic church art owes something—perhaps a very great deal—to a change in theological outlook on the natural world. Again it was a figure in Christian theology who drew back the curtain, but a more significant figure by far than Grosseteste. He was the Italian theologian St Thomas Aquinas, the most influential church thinker of the Middle Ages.

Aquinas rejected the traditional Platonists' verdict that the physical world was only a snare and that Christians had an obligation to rise above it. Instead, the view of creation he proposed was that everything in this world partakes of God. And this benign outlook Aquinas owed, not to Plato, but to Plato's pupil Aristotle, who had hitherto been regarded by Christians as a heretic for not having engaged his mind upon matters of the after-life.

Aristotle's view, which Aquinas succeeded in making respectable to Christianity, was that all things on this earth are fundamentally good; that the materials of the good life lie here around us, and man has the choice to embrace or reject evil. In other words, the world about us can be our guide to perfection if we choose. Aquinas, therefore, envisaged man working *with* nature, not *against* nature. It lay within the capacity of man to transform this world into a perfect world—into, in fact, a Garden of Eden. It was as though chains were removed from the human spirit. In the history of the relationship between the Church and the natural world there has been no change of thought as momentous as this.

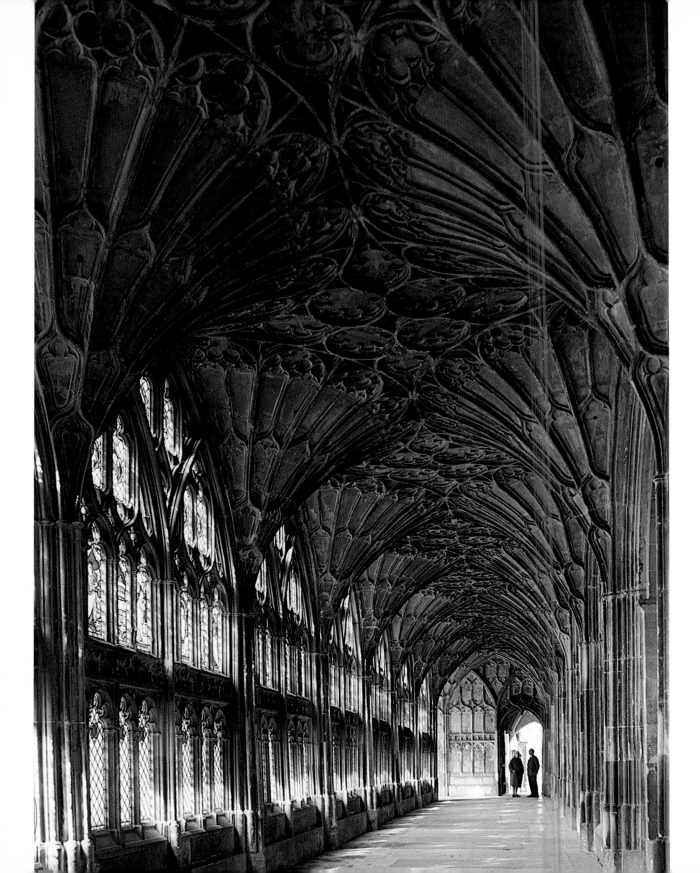

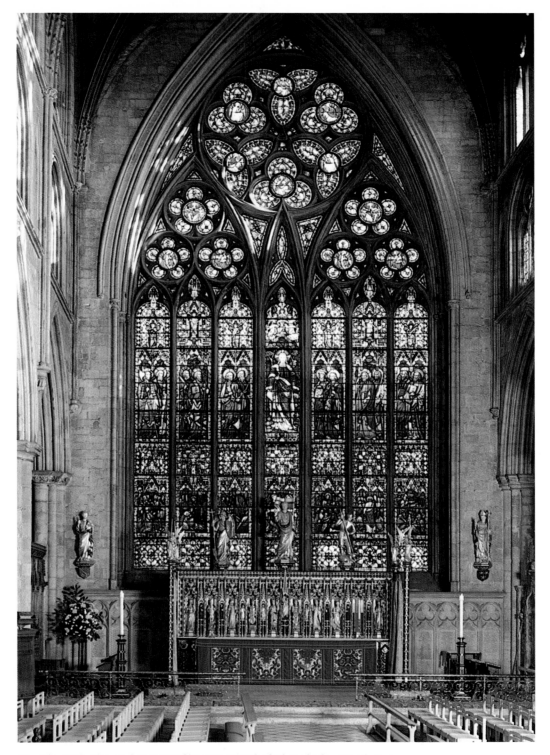

41 The High Altar and East Window, Ripon Cathedral. Early fourteenth century.

OPPOSITE 40 The Great Cloister, Gloucester Cathedral. Late fourteenth to early fifteenth century.

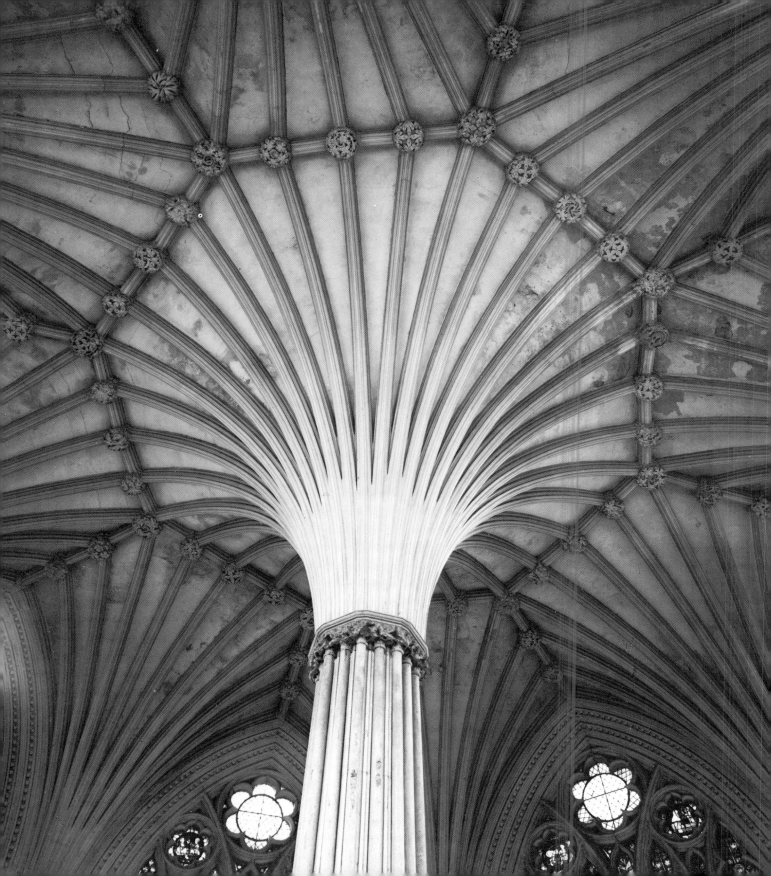

In the decades that followed the death of Aquinas in 1274, an awakened response to the natural world is mirrored in church architecture throughout Europe; and in England this response—expressed in the abstract language of engineering—was of a wonderfully ecstatic kind. In a recent work on Gothic churches of the period, *The English Decorated Style*, Professor Jean Bony summarizes that achievement in a few sentences which shine out of the cautious scholarship. 'English art of the early years of the fourteenth century has a visionary quality of irrepressible inventiveness: nothing was left untouched by it. A new dream had seized the imagination of a most imaginative race.'

At the heart of this dream was a longing to evoke from inanimate stone a sense of organic vitality: not to copy nature but to capture in architecture its spirit and its energies, as well as to learn lessons from the forms of nature which could be applied to the technology of building.

The inventiveness of English stonemasons was astonishing and varied. The vault at Southwell, completed about the year 1300, seems to hover over the chapter-house like the star of Bethlehem. At Wells, less than twenty years later, the chapter-house was larger in diameter and so required a central support. All that was technically needed was a pillar and some kind of vaulting above. But this was enough to set the imagination of the builder racing. When you mount the stone staircase from the body of the cathedral, and follow it as it divides to the right into the chapter-house, you are confronted by a column in the centre of this octagonal room that rises far above your head and then sprays outwards into a fountain, as it seems, frozen into stone, or the trunk of a tree that bursts into thirty-two branches, each one of them ending in a boss of tight foliage.

The English dream: how to hold a roof up, and yet make the stone feel as light as leaves. How to take the experience of gazing upwards at a giant tree, and then translate that experience into the dynamics of a building raised in honour of God. There is no sentimental imitation of nature here, yet it is one of the loveliest manifestations of the English love of nature.

The Lady Chapel at Wells was built some twenty years after the chapter-house. A vault more complex than the one at Southwell spreads across the ceiling: another star. Below it on three sides is an arc of five windows. The tracery is repetitive and simple: slender bars of stone divide the main area of each window into five vertical blades of glass. Above them, as the arches begin to taper, these verticals break into a pattern of three-lobed shapes—four, then three, two and finally one under the point of the arch. Simple. Pure geometry.

And yet—what is pure geometry when you stand in this light-filled place? The three-lobed tracery owes its origin to the form of a flower. If there were no flowers it would not exist. Light is broken up into a pattern of petals repeated over and over again. Naural forms and architectural forms are bridged by the imagination of the stonemasons. And those of us who gaze at their work find that bridge an effortless one to cross.

This same miracle of transformation—organic form re-created in stone—takes place in the tracery of cathedral windows all over the country during the first part of the fourteenth century. My own favourite is at Lincoln, at the end of the south transept—a window

OPPOSITE
Vaulting in the early fourteenth-century chapter-house of Wells Cathedral, Gloucestershire.

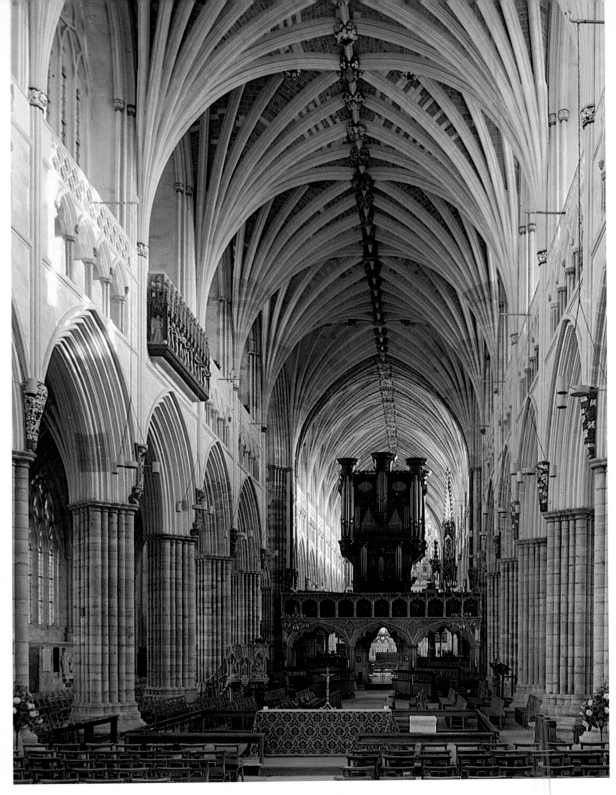

42 The Nave, Exeter Cathedral, with mid-fourteenth-century vaulting.
43 Fan-vaulting in the Henry VII Chapel, Westminster Abbey. Early sixteenth century.

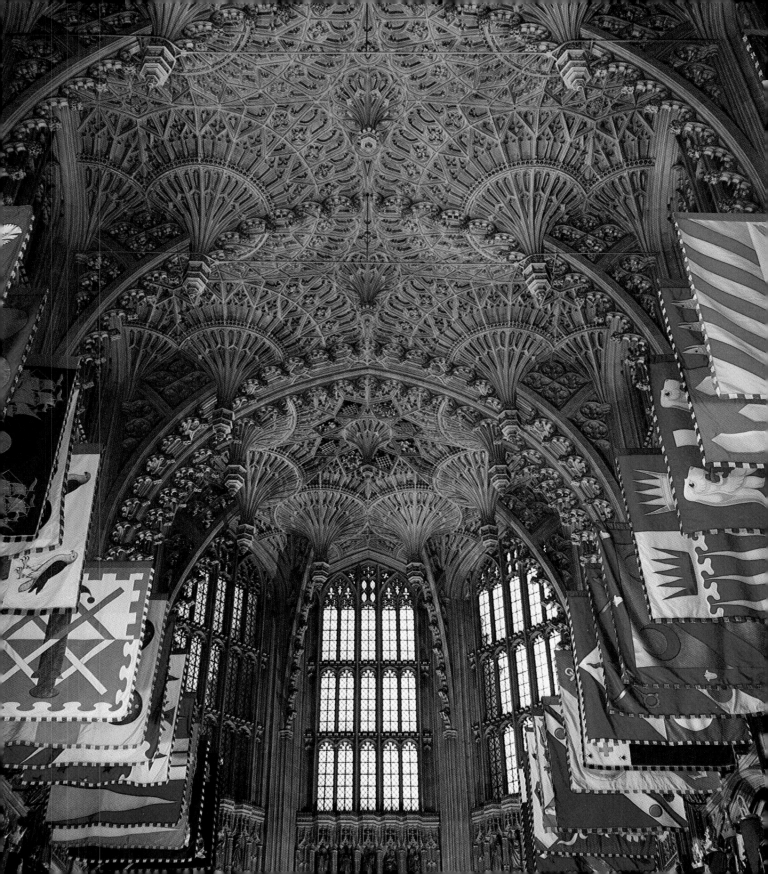

known as the 'Bishop's Eye'. It is circular, set below the arch of the wall; and within the circle, almost filling it, spread two enormous leaves. Veins of tracery run across each leaf, breaking up the surface into areas of space filled with coloured glass. We do not know what images they contained since the original glass is lost, and what is now here is a motley of fragments from all over the cathedral. But the window is south-facing, and from whatever angle the sun shines it has the effect of transforming these two giant leaves into trees that are ablaze with blossom.

Visions of nature fed the imagination of English church-builders like sap. A man born at the end of the thirteenth century could have seen all these magnificent windows completed if he lived to be forty. And if he survived the Black Death of 1348 and lived on to be seventy he could have walked down the nave of the most sumptuous of all English Decorated cathedrals, Exeter; and he could have gazed up at a vaulted roof that is one of the supreme triumphs of English Gothic (Plate 42).

Here is a 300-foot stretch of vaulting in which every rib that fans outwards from the wall to meet its counterpart at a central boss serves the functional purpose of supporting the roof. It is a piece of marvellous engineering, and it can be explained as such. It generally is. Yet to do so overlooks the visual imagination of the English church-builders for whom functional purposes was only a beginning. It overlooks, too, the imagination that we are invited to bring to it when we gaze upwards. Here at Exeter is one of those bridges between the experience of engineering and the experience of the natural world which Gothic building—more than any other—offers to those who allow themselves to fall under its spell.

Anyone who walks down the nave of Exeter Cathedral is aware of being engulfed by a wonder of architecture. And to that person I would ask two questions. If the master–mason had never walked through a forest and raised his eyes, could he ever have designed it? And if we, the spectators from the twentieth century, had never done so, would we be capable of responding to it?

English church-builders were reluctant to give up the Gothic style. They loved it, and they went on loving it long after it was thought to be outdated and barbaric in those European countries which considered themselves to be progressive.

At the beginning of the fifteenth century the imagination of Italian church architects was already fired by the ideals of a new classicism that derived from the monumental buildings of Ancient Rome. The achievements of Brunelleschi in Florence, like the Pazzi Chapel and his celebrated cupola of Florence Cathedral, turn their back on the ecstatic mysticism of the Gothic world and in its place offer quite different ideals—those of harmony, proportion, mathematical perspective and the rule of reason. But in England the dream remained undisturbed; in fact it became increasingly fantastical as church-builders strove for ever more inventive vaulting to express an ever more ecstatic vision of God's house.

At the same time that Brunelleschi was creating the new architecture of intellect, the masons of Gloucester Abbey (now Gloucester Cathedral) were elaborating that English Gothic dream of an architectural heaven. In the new cloisters they employed a form of roof vault which

had no precedent or parallel on the Continent, and which was to guide English Gothic to a breathtaking climax over the next hundred years (Plate 40). This was the fan-vault. All those branches meeting overhead in earlier Gothic vaulting have now formed the lace-like geometrical pattern of a fan.

Gloucester was only the beginning. Gothic architecture is about looking upwards, and in the fifteenth and early sixteenth centuries the fan-vaulted roof became the perfect canopy for some of the loftiest and most exalted achievements in English architecture. There are not, alas, a great many of them: most of the great cathedrals were already completed, and the sheer expense of fan-vaulting placed it far beyond the means of the ordinary parish church, unless some exceptionally generous benefactor made provisions for such opulence, as occurred at Cullompton, in Devon. Generally, fan-vaulting was for grander places, like the choir of Christ Church Cathedral in Oxford, and the rebuilt Bath Abbey. The most splendid monuments of fan-vaulting were a series of individual chapels of immensely wealthy private endowment: St George's Chapel at Windsor Castle, King's College in Cambridge, and finally—most triumphantly —the chapel of Henry VII in Westminster Abbey (Plate 43).

As we gaze up at that extraordinary web of stone that seems to be floating above

Strawberry Hill, Twickenham: the Gothic villa of Thomas Walpole, remodelled 1750–75.

Henry's chapel we know, because all the books have told us so, that here is the grand finale of English medieval architecture. All that swagger and showmanship above our heads is both a crowning and an abdication: it is the end of the Middle Ages, and the birth of the Tudor Renaissance.

But there is something else that has abdicated almost without our having noticed it. As our eyes follow the pyrotechnics of fan-vaulting the imagination is no longer stirred by that Gothic dream of nature re-created in stone. This is not like Wells, or Exeter. The roof of God's house has become, in its intricate English way, just as much the architecture of intellect as the churches of Renaissance Italy that were inspired by the classical ideals of Brunelleschi and his follower Alberti. In the imagination of English church-builders the mirror of nature has been replaced by something much more narcissistic—the mirror of man's own sheer cleverness.

After the splendours of English Perpendicular and the high-wire showmanship of fan-vaulting, you might have imagined that English Gothic had nowhere left to go. And with Inigo Jones and Wren, then Hawksmoor and Vanbrugh, and finally eighteenth-century Palladianism, you might have assumed that ideals rooted in classical Italy were here to stay. Yet the Gothic dream did not die. It re-emerged in the form we know as Gothic Revival.

Architectural historians, who sometimes feel more comfortable with the style of a building than with the spirit of it, tend nowadays to disclaim any connection between true Gothic and the natural world, and in running an argument for it I have been running the gauntlet of their disapproval. But with Gothic Revival there can be no argument at all. Nature was an obsession in eighteenth-century England, and the beauty of nature became the Revivalists' gospel. Classicism clearly had nothing to do with nature at all; what is more, being rooted in Ancient Greece and Rome, it had nothing to do with God either.

Accordingly, the proper and correct style of architecture for churches was one that had actually been created by the Christian faith, and one that drew its inspiration from the natural world: in other words, Gothic. Pointed arches, intricate vaulting, decoration taken from nature: these things were synonymous with a religious spirit. To the Revivalists the Gothic style *was* in itself religious.

Paradoxically, the eighteenth century was not a particularly religious age. There was not much call for new churches: England had enough already. Gothic nostalgia in its early manifestations took the form of self-indulgent whimsicalities such as the cult of ruins and the proliferation of grottoes on private estates that were remodelled in the Gothic spirit. Alexander Pope created a celebrated grotto in his garden at Twickenham. In the middle of the century Thomas Walpole bought Strawberry Hill and transformed it into a Gothic fantasy, ruins and all. And at the end of the century William Beckford commissioned a ruined convent, Fonthill Abbey, and then decided to live in it, adding some more or less habitable features, including an octagon tower nearly three hundred feet high.

The Gothic Revival might have lived and died a folly of the rich had it not been for the Industrial Revolution. Farm workers flocked to the new industrial regions for employment:

44 John O'Connor, *St Pancras Hotel and Station from Pentonville Road; Sunset*. Oil. 1884. Museum of London.

within a few generations villages became towns, market towns became industrial cities, and the population of England exploded. Suddenly there was a dearth of churches: in the emptying countryside there were more than enough already, but in the new industrial sprawls in the Midlands and North, and around London, there were scarcely any. What is more, the nineteenth century was witnessing a resurgence of religious fervour.

It was in response to this situation that the Gothic Revival came into its own. Faith replaced folly. The Church Building Act of 1818 made generous grants available for new churches, principally in these new urban areas, and within fifteen years six million pounds was spent on church building in England. In the London area alone it is known that 174 churches in the Gothic style were constructed within a few decades.

Soaring vaults, flying buttresses, carved portals, capitals, pews and pulpits, dreaming spires piercing the smoke and smog towards heaven: church-builders tried to evoke a long-lost era when man lived in harmony with God in God's green land, for the benefit of a society hell-bent on destroying God's green land as fast as possible.

It was a victory of nostalgia over realism. And increasingly this was what the relationship between English nineteenth-century architects and medievalism was to become. As industrialization advanced, the medieval dream grew more and more vivid. It infected every kind of building the Victorians put up: not only churches, but railway hotels like St Pancras in London (Plate 44), the Law Courts in the Strand, the University Museum in Oxford, the Manchester Town Hall, even a carpet factory in Glasgow.

And, of course, the Houses of Parliament. You might imagine that the Mother of Parliaments, as it held the reins of the leading industrial nation in the world as well as wielding authority over more than one third of our planet, would be at the furthest possible distance from dreams of forests and wild flowers. Yet one of its two architects, Augustus Pugin (the other being Sir Charles Barry), was a man who claimed to have found real plants to be the source of every example of Gothic ornament in the medieval world. He published his findings in *Floriated Ornament*, 1849, including illustrations to prove his point. And in *True Principles of Christian Architecture*, 1841, he wrote that buildings should look 'as if they formed a portion of nature itself, grappling and growing from the sites in which they are placed.'

City or countryside, the nineteenth-century vision of God's nature was pervasive. The church was a link between a new and an old England. And when, later in the century, William Morris and the Arts and Crafts Movement inspired a whole philosophy of traditional country values in opposition to the march of industry, what feels like a counter-revolution was actually the nurturing of a spirit which had been there all the time.

It seems to have been in the character of nineteenth-century Englishmen to be in the grip of a paradox they could never resolve. They strove with all that tremendous Victorian energy to fulfil William Blake's prophecy of building a New Jerusalem in England's green and pleasant land; yet they could never decide whether what they were achieving represented Paradise Regained, or Paradise Lost.

OPPOSITE
Pages of illustrations
from Augustus Pugin's
Floriated Ornament.
1849. London, Victoria
and Albert Museum.

Examples of Ancient Floriated Ornament.

NATURE AND
INDUSTRY

n the eighteenth century, even well into the nineteenth, it was perfectly possible to view the awesome inventions of science without having any thought or fear that the appearance of England—or the English economy and way of life—might be fundamentally changed by them. Even the steam engine and the railway, in their infant stages, seemed no more likely to transform England than did the first cars, aeroplanes, television sets and computers in the twentieth century. Accordingly, the English countryside, and nature generally, seemed safe, and early paintings and watercolours of industrial scenes reflect this confidence that all was entirely well. Industry merely provided welcome new motifs in the landscape of the picturesque.

But by the second quarter of the nineteenth century this was no longer so. The character of the economy *was* changing—rapidly. So was the pattern of English life. And so, quite dramatically, was the face of England. For the first time in history a man could look around him in his middle age and say that it was no longer the country he was born into. He could look at a picture of the land of his youth and say that he no longer recognized it.

The Industrial Revolution transformed England from a rural into an urban country, or at least huge tracts of it. The peasant became the proletarian. Suddenly more people lived in towns than in the countryside. And the population increased on a scale hitherto unknown. If you had been born in England in the year 1800 you would have been one of fewer than ten million people. By the time you were forty, numbers would have increased by almost seventy per cent, as much in those forty years as in the previous four hundred years. And if you managed to live till you were eighty, the population would be more than three times greater than in the year that you were born. As a result, an increasing number of people never knew what the countryside was. The *natural* environment ceased, in fact, to be nature at all. It was man-made.

What is noticeable in the early decades of the century, and it is reflected much more strongly by English writers than by painters, is a gradual shift in outlook from a welcome extended towards this advance of urban industrialization to a mounting unease at its disruptive effects. The leading English nature poet of the day, William Wordsworth, expressed this change of outlook in his own writings.

In 1802 he could envisage a happy union of art and science to which the poet would extend his godlike blessing. 'If the time should ever come when what is now called science . . . shall be ready to put on, as it were, a form of flesh and blood, the Poet will lend his divine spirit to aid the transfiguration, and will welcome the Being thus produced, as a dear and genuine inmate of the household of man.'

Resounding—if pompous—words! And yet, in the eighth book of *The Excursion*, composed only some ten years later, Wordsworth was putting into the mouth of his Wanderer a far more lugubrious account of the impact of science on contemporary England:

> An inventive Age
> Has wrought, if not with speed of magic, yet
> To most strange issues. I have lived to mark

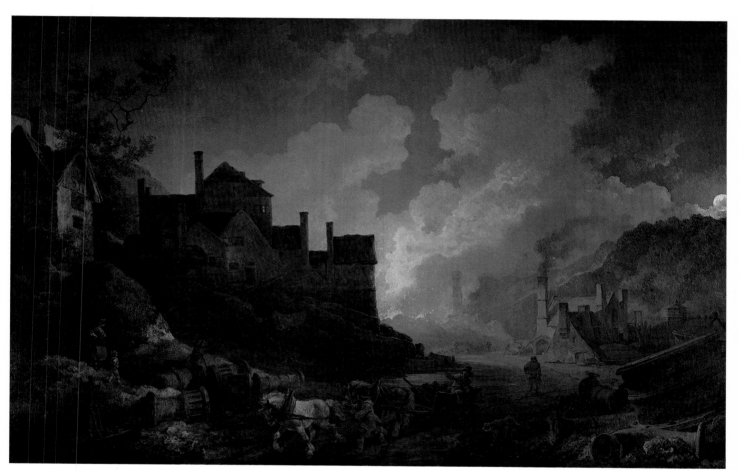

45 Philippe Jacques de Loutherbourg, *Coalbrookdale by Night*. Oil. 1801. London, Science Museum.

A new and unforeseen creation rise
From out the labours of a peaceful Land
Wielding her potent enginery to frame
And to produce, with appetite as keen
As that of war, which rests not night or day,
Industrious to destroy!

The emphasis is no longer on science fathering some dear inmate of the household of man, but on its power of destruction. And the Wanderer goes on at gloomy length to describe poor hamlets transformed into towns hiding the face of the earth, over which the smoke of unremitting fires hangs permanently. This is how Wordsworth came to view the new landscape of England. He saw rural life under threat, and nature under threat. And he voiced a feeling— already becoming widespread—that things were getting dangerously out of hand.

It was much more than a traditionalist's grumble at forces of change. Before the Industrial Revolution no one in England is likely to have considered seriously that man might become bigger than nature: that he might control her, plunder her and—if he chose to—destroy her. Now there was a conflict where none had existed before: the dream of human power and progress on the one hand, and on the other a state of harmony with the natural world by which man had always lived. The question was—could, should, man actually kill nature?

English painters, by and large, failed to address themselves to such a question. The reaction of most artists to the upheaval around them was to pretend it was not actually happening. Their clients, after all, were still for the most part the landed gentry who also liked to pretend that it was not happening.

Here and there a few painters did respond to the new industrial landscape. In particular there were the English watercolourists, who were combing the country in search of views, sights, picturesque places which could then be worked up into attractive engravings and sold to an urban clientele which had never visited such places and probably never would. And here industrial scenes did find a niche. In the era of the romanticized landscape scenes of factories and furnaces could be made to appear awesome and wonderful, a dramatic accompaniment to nature comparable to a thunderstorm or a sunset.

The East Anglian artist John Sell Cotman was among the most gifted of these itinerant view-painters. His watercolour of Bedlam Furnace, painted at the very beginning of the nineteenth century, is a striking example of how the new world could be represented as perfectly harmonious with the old. Across the blue waters of a lake the furnace burnishes the evening clouds the softest shade of russet-red above a glare of white. Smoking chimneys reflect in the waters just as poetically as one of Richard Wilson's medieval castles. And in the foreground a peasant treads his peaceful path by the lakeside as if the rustic harmony of man with nature were unbroken and eternal.

Then there were attempts to make the new landscape of industry look as though it belonged to great antiquity. There is a coloured aquatint of the Iron Works at Coalbrookdale,

engraved by William Pickett after a painting by De Loutherbourg (Plate 45), which was included in the artist's *Picturesque Scenery of England and Wales* of 1805. Unlike the Cotman, there is no attempt to hide the industrial nature of the subject: the scene is in broad daylight, and close enough to show smoke and flames from the chimneys.

The cunning of the artist was to make a modern industrial subject appear hallowed, timelessly beautiful, almost a shrine on which the cultural pilgrim might rest his eyes with joy. De Loutherbourg's iron works nestle within a fold of green hills like ruined temples in Italy; and in the foreground lie discarded bits of boiler machinery scattered in elegant disarray as if they were columns fallen beside the Appian Way, cherished fragments of a distant classical civilization.

This appeal to antiquity was by no means the prerogative of artists striving to endow industrial subject-matter with pictorial charm. Architects and engineers played much the same game. For instance, the new canal system that was now threading the English country-side required huge aqueducts; and where else would a designer look for his model but the aqueducts that strode across the Roman Campagna?

Artists responded in the same spirit. They painted these new giants of engineering

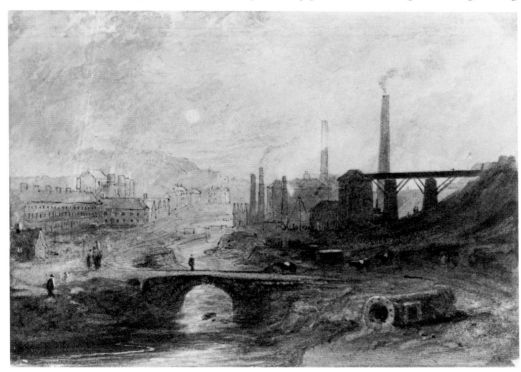

Nant-y-glo Ironworks. Watercolour attributed to George Robertson. 1788. Cardiff, Welsh Industrial and Maritime Museum.

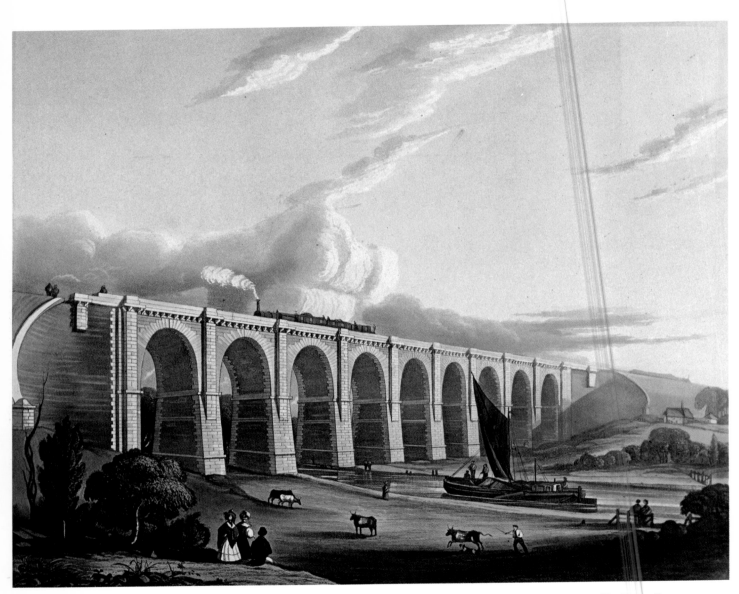

46 T. T. Bury, *The Viaduct Across the Sankey Valley: Liverpool and Manchester Railway*. Coloured aquatint engraved by H. Pyall. 1831.

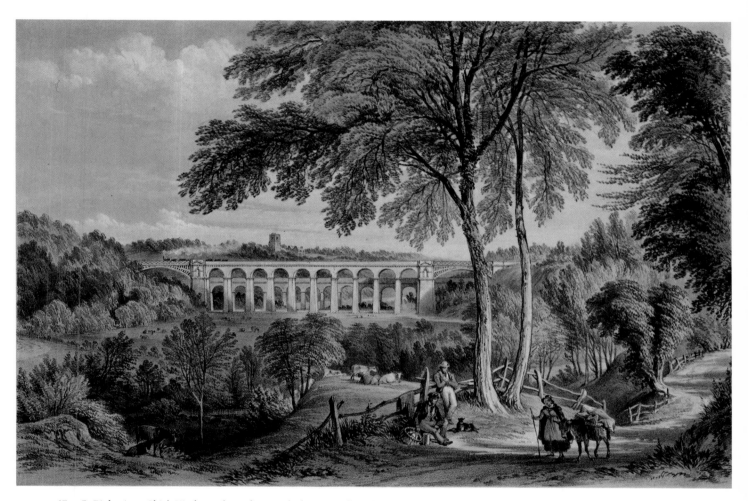

47 G. Pickering, *Chirk Viaduct: Shrewsbury and Chester Railway* (aqueduct beyond). Coloured lithograph by George Hawkins Jnr. 1848.

with little figures standing around in awe, as if they were monuments to a great cultural past sleeping quietly in the Italian countryside and they had just come across them on the Grand Tour (Plates 46 and 47). For the past hundred years artists had been making the pilgrimage to Italy in the company of English milords to record the classical landscape associated with the Golden Age of Rome. The great Roman bridges and aqueducts were seen to enhance the Italian landscape and to be embraced by it. Here was a historic marriage of man's genius and nature's beauty, and the example of it helped colour that peculiarly English nineteenth-century dream of a modern Renaissance in which science and nature, science and art, could all come together in unison to the greater benefit and triumph of mankind.

In practice, this splendid ideal of the new industrial Renaissance consigned nature to a cosy and nostalgic role. As the century advanced, and industry took a firmer grip on England's economic life and landscape, the view of nature that is mirrored in early Victorian painting is of a pretty and rather quaint survivor—not entirely real any more, but perfect for picnics, for dreams, and for sentimental tableaux of rustic life.

Nature is the old world, but it is an old world that makes the rather frightening new world feel more acceptable. Most often it is what makes it possible for artists to confront the new world at all. Nature is the sedative, the comforter. Topographical artists collecting views like botanical specimens could no longer ignore the march of science because it was now every-where. But they could dress its new landmarks in the most reposeful of scenery, and so muffle its iron tread.

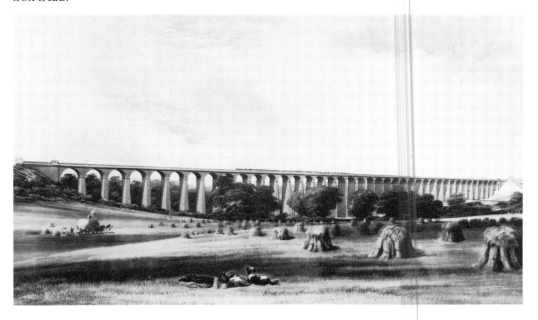

W. Humber, *Welwyn Viaduct*. Watercolour. 1850. Ironbridge Gorge Museum, Elton Collection.

Hence, some of the most idyllic English landscape paintings and watercolours of the mid-century are actually of that new god of progress—the railway. One of my own favourites is a watercolour of the Welwyn viaduct, painted in 1850 by an artist I believe nothing whatever is known about except his name—W. Humber. The picture is a lyrical account of Old England nestling peacefully under the New. The old world is most lovingly described. The land is rich. Corn has been ripened in the sun. It has been skilfully harvested into stooks by a team of farm-labourers who are now forking the sheaves up into a cart in the middle distance, while a dog faithfully guards their lunch in the foreground.

It might be a Victorian advertisement for the good life. Yet already this is a nostalgic vision because overtopping everything—the fields, the diminutive figures, even the giant oak-trees—strides the railway, pointing the way to progress and the New England.

Like the aqueducts earlier in the century, the great railway bridges and viaducts brought a touch of Roman grandeur to the English countryside. And just as rapidly, railway stations were bringing a new kind of medieval grandeur to English cities. Here were the new cathedrals to the new god. The first of the major railway termini was Temple Meads Station at Bristol, built in 1839 by that Michelangelo of the Railway Age, Isambard Kingdom Brunel. And to cover the seventy-two-foot span of the train-shed Brunel found his model—where else could he have found it?—in medieval English halls and churches. He designed a hammer-beam roof, in timber.

The new technology then took over, leaving the Middle Ages behind. When

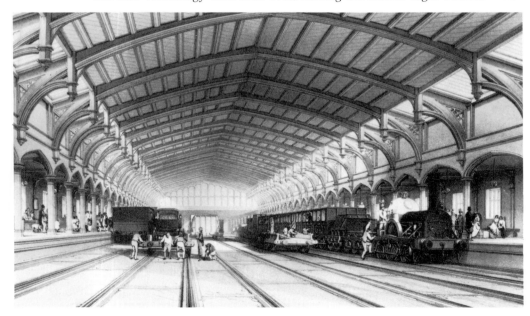

Temple Meads Station, Bristol. Tinted lithograph by J. C. Bourne. 1846.

48 J. M. W. Turner, *Snow Storm—Steam-Boat off a Harbour's Mouth*. Oil. 1842. London, Tate Gallery.

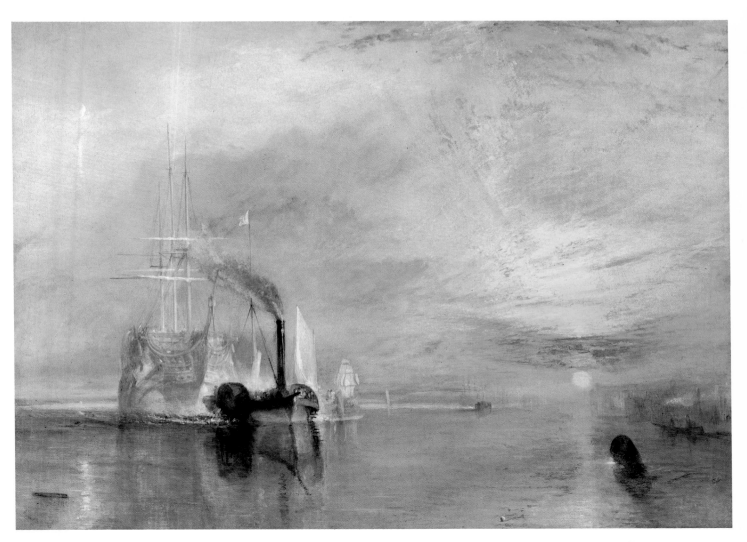

49 J. M. W. Turner, *The Fighting 'Téméraire' Tugged to Her Last Berth To Be Broken Up*. Oil. 1839. London, National Gallery.

Newcastle Central station was built in 1848, the architect John Dobson designed what was to be the prototype of all modern railway stations: this was a high vault between platform and platform that was ribbed entirely with iron, the whole structure having the added elegance of following the long curve of the tracks below. With the new iron vaulting the span of these station roofs grew wider and wider. At Charing Cross in 1863 the lines and platforms were covered by a single enormous span of 164 feet; and even this looked narrow five years later when W. H. Barlow bridged the entire width of St Pancras with a span of steel and glass 243 feet across—the widest permanent roof span anywhere in the world until well into the present century.

It was all happening so rapidly, invention chasing invention, engineers outdaring each other, all in a matter of a few decades. No wonder so few artists in mid-nineteenth-century England—even topographical artists whose livelihood depended on their eye for a new view— came to terms with the technological revolution that was breaking around them. Not many art patrons, after all, wanted a picture of a railway terminus in their collections.

There was, however, a flourishing market in illustrated books. The scope of subjects that found purchasers was a good deal wider than it was in the fine art world, and books which recorded the new wonders of science found some commercial success. The most enter- prising publisher of illustrated books in early nineteenth-century England was a German immi- grant by the name of Rudolf Ackermann. Thomas Rowlandson worked for him, and so did a number of well-established landscape watercolourists, including Paul Sandby, Edward Dayes, Michael Rooker and W. H. Pyne. Success in publishing views and travel books encouraged Ackermann to branch out, and in the 1830s he began to publish views of the new railways.

So it was that the most exciting industrial development of the day began to win a respectable place in art as an extension of landscape painting—on the back of nature. Ackermann's artists popularized the view that the wonders of the railway network could be enjoyed as if they were really a wonder of nature. The most gifted artist he employed to illustrate this was John Cooke Bourne. Too little has been written about Bourne. The historian Sir Arthur Elton referred to him strikingly as 'the Piranesi of the Age of Steam' in the *Country Life Annual* for 1965. The most accessible account of his work is in Francis Klingender's masterly study entitled *Art and the Industrial Revolution*, which Elton edited and revised in 1968.

Bourne has left us the most vivid record we have of the railway boom in England. He 'covered' it as a pictorial journalist during the 1830s and 1840s, publishing two portfolios of lithographs—the first on the London and Birmingham Railway, the second on Brunel's Great Western Railway—as well as making numerous wash drawings done on the spot as preparatory studies.

Bourne's artistic training was in the topographical tradition of the eighteenth and early nineteenth centuries in which the rule of nature was unchallenged, and man's works were seen to blend into nature and be subservient to her rule. He was now engaged in recording events which could not honestly be said to respect these priorities. His drawings suggest a man struggling to keep the peace with the natural world he knew and trusted, while reporting an occurrence which was ripping that world apart.

Of all the winds of change that have altered the English view of nature since the Middle Ages—reflected in churches and church art, in poetry, in landscape painting and in the decorative arts—the one that blew with the Industrial Revolution was surely the most dramatic and the most disturbing to those who felt the force of it, because for the first time it struck at the supremacy of the natural world: it hoisted man's supremacy instead. And it is in this conflict between a traditional respect for nature and a respect for the energies of man, that these modest and little-known sketches by John Bourne hold an importance larger than their value as works of art.

It is Klingender who points out the contrast between the view of the railways expressed by artists like Bourne and the exactly contemporary view of the novelist Charles Dickens. Several of Bourne's most sensitive wash drawings are of excavations being made around Camden Town to make the deep cutting for Robert Stephenson's new London to Birmingham line from Euston. The drawings are lyrical, bathed in sunlight; there is nothing about them of menace to man or nature.

But while Bourne was sitting sketching, Dickens was also an eye-witness, and the novelist's account of what he saw later appeared in *Dombey and Son*. Unlike Bourne, he found the scene profoundly disturbing. This is what he wrote:

> The first shock of a great earthquake had, just at that period, rent the whole neighbourhood to its centre. Traces of its course were visible on every side. Houses were knocked down; streets broken through and stopped; deep pits and trenches dug in the ground; enormous heaps of earth and clay thrown up; buildings that were undermined and shaking, propped by great beams of wood. Here, a chaos of carts, overthrown and jumbled together, lay topsy-turvy at the bottom of a steep unnatural hill; there confused treasures of iron soaked and rusted in something that had accidentally become a pond. Everywhere were bridges that led nowhere; thoroughfares that were wholly impassable; Babel towers of chimneys, wanting

ABOVE LEFT
The title page of
J. C. Bourne's *The
Great Western Railway*,
published 1846. Tinted
lithograph. Ironbridge
Gorge Museum, Elton
Collection.

ABOVE
J. C. Bourne, *No. 2
Tunnel, Bristol*. Litho-
graph. 1845. Ironbridge
Gorge Museum, Elton
Collection.

50 John Linnell, *Under the Hawthorn*. Oil. 1853. City of Aberdeen Art Gallery.

51 Myles Birket Foster, *Girl with the Orange*. Oil. *c.* 1870. Bristol Museum and Art Gallery.

half their height . . . There were a hundred thousand shapes and substances of incompleteness, wildly mingled out of their places, upside down, burrowing in the earth, aspiring in the air, mouldering in the water, and unintelligible as any dream.

Nature threatened, or nature enhanced? The conflict between these two opposing verdicts on the march of industry is sharply illustrated by Dickens and Bourne: two pairs of eyes that looked at the identical event and saw something quite different.

Bourne's account of the railways is a triumph of presenting the new world living in harmony with the old: industry and landscape belonging together. On the title-page of *The Great Western Railway* Bourne even indulged in the fancy of showing its name, along with his own, actually engraved into the hillside above the entrance to one of the tunnels, with plants tumbling over the inscription to suggest that it had been there for centuries.

Even the great Brunel, most modern of men, did the same when he designed the tunnels themselves. Beneath the inscription on the title-page the tunnel entrance (now destroyed) resembles most carefully a medieval church door. Another entrance Brunel deliberately left incomplete so that it would look like an ancient ruined gateway. And he trained ivy over it to make it more picturesque, more in keeping with the fashion for pretty ruins. Here were monuments to the nineteenth-century English dream of a true marriage between science and art, sanctified by the blessing of nature.

The welcome that John Bourne gave to industry was a reassurance that the landscape could absorb it quite peacefully. Nothing need change. The birds would go on singing. Of course Bourne was falling over backwards to deny what industry was about. Dickens, the social commentator, perceived it to be cataclysmic, an earthquake that shattered the norm of people's lives. But until the emergence of illustrated journalism in the middle years of the century artists in England were not by and large employed to be social commentators. The artists who undertook to record the progress of science were view-painters for whom people were mere decorative effects in a landscape. Significantly, *The Spectator* praised Bourne for revealing 'new features of beauty to the English landscape painter'.

The resistance to looking at industry head-on, so to speak, came from the persistence of the English landscape tradition. Hence it is appropriate that the one English painter who did embrace industry wholeheartedly did so by broadening his vision of landscape so that it included industry—indeed actually celebrated industry. He was J.M.W. Turner.

Turner painted his celebrated *Rain, Steam and Speed—The Great Western Railway* in 1844, at the very time that John Bourne was completing his portfolio of studies of the same railway. In fact Turner's train is crossing one of Brunel's great bridges—at Maidenhead—which Bourne had recently drawn. It would be hard to recognize it as the same place. The novelist Thackeray, in his review of the 1844 Royal Academy Exhibition, commented, 'As for Mr Turner, he has out-prodigied all former prodigies. . . . The world has never seen anything like this picture.' Indeed, the world had never seen a train or a railway represented like this before.

Turner was not in the least interested in making trains look rustic. Here was not a

subject for haymaking and cows, or for echoes of the Roman Campagna. There is just swirling mist and smoke. Turner liked trains: he liked travelling on them, and what excited him about them were precisely those things that other artists took such pains to hide—dirt, noise, speed, energy. He did not perceive the railway as a threat to nature. It *was* nature. Fire and water combine to produce steam: man had merely learnt to harness this power. There could be no possible separation, therefore, between industry and nature: they employed the same forces and contributed to the same drama.

This mingling of man's power and nature's power is one of Turner's most majestic themes. In *Rain, Steam and Speed* the cowl of the train's engine has been omitted in the painting so that we may see right into the furnace, as if we were looking into the heart of a volcano. In *Snow Storm* a steamboat at sea sends up a plume of smoke and fire that blends with the swirl of storm-clouds and blizzard (Plate 48). In *The Fighting 'Téméraire'* a sailing ship from the Battle of Trafalgar is towed to the breaker's yard by a steam-tug—the old world buried by the new (Plate 49). And the tug-boat's funnel sends out a salute to the old warship which is an echo of nature's salute all around it—the most spectacular of sunsets that fills the sky with fire and stains the water scarlet.

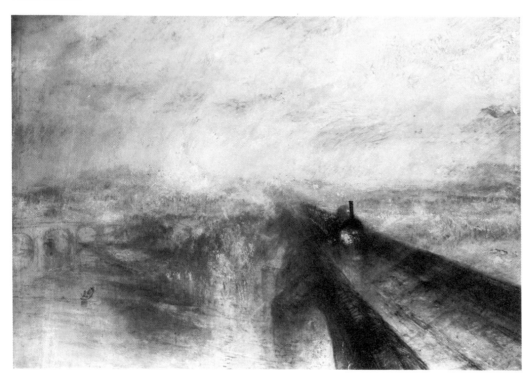

J. M. W. Turner, *Rain, Steam and Speed—The Great Western Railway*. Oil. Exhibited 1844. London, National Gallery.

52 The Great Exhibition building in Hyde Park. Chromolithograph. 1851. Ironbridge Gorge Museum,
Elton Collection.

OPPOSITE 53 The interior of the Great Exhibition building in Hyde Park: the south transept. Chromolithograph. 1851.
Ironbridge Gorge Museum, Elton Collection.

The march of the railways exerted a massive influence on how people in general saw the world about them in nineteenth-century England. For the first time it became possible to enjoy nature as a passing spectacle, a picture show; something to be viewed in relative comfort, high up and from a distance. Nature in Victorian painting becomes a pretty view from a bridge—a prototype travel poster—a picture to take home to the town and remind you of summer holidays. Artists such as John Linnell and, later in the century, Myles Birket Foster, were concerned to sentimentalize the countryside, populating it with coy and unreal figures guarding sheep or playing rustic games (Plates 50 and 51). Theirs was a confection of nature for a townee's consumption, with all marks of the Industrial Revolution sugared over.

'The locomotive', wrote Samuel Smiles, 'gave a new celerity of time. It virtually reduced England to a sixth of its size. It brought the country nearer to the town, and the town to the country. . . .' In 1830 there had been just thirty-one miles of track for passenger trains in England. By 1854 it was nearly 9000 miles. Railways covered England, Wales and Scotland like a web. And as a result trains opened up the countryside to large numbers of people who were not countrymen and might otherwise never have seen it. Nature became something it had never been before: a collector's item.

The Victorians, it must be said, collected everything. Theirs was the world's first consumer society. Their domestic ideal was clutter, and they barricaded themselves within it until they could scarcely breathe. Transport, which made the landscape of Britain more available, also made the products of Britain more available. The Victorian home became a fortress of possessions.

Here lies one of the major contradictions of nineteenth-century England. So much of the cherished clutter of the Victorian home was provided by industry: the china ornaments, the cottons, the chintzes, the carpets, the prints and the printed wallpaper, the ironwork, the elephantine dressing-tables and writing-desks, the encrusted *tazze* and *jardinières*. But, at the same time, if you look at these amazing mass-produced goods, you notice that a great many of them celebrate the very idyll of nature that industry was dedicated to destroying. Even lavatories, once modern plumbing and sewage systems were introduced during the 1880s, paid their homage to nature, their basins enamelled like temples of Flora. Home sweet home!

It was Oscar Wilde who said that every man destroys the thing he loves; and the Victorians were prime exponents of this dictum. They destroyed nature, and they cherished it. Very often the two attitudes flourished side by side. The paintings of Landseer are one illustration of this ambiguity (as I recounted in Chapter Three). The Victorian home provides another. In the spaces between the clutter of furniture and memorabilia they demonstrated a morbid affection for nature in its destroyed state. Anything they could kill they brought home as a trophy. Birds and butterflies galore were stuffed and pinned to satisfy the new vogue for collecting specimens. Wild animals—the rarer the better and best of all if extinct—presided over hallways and mantelpieces like holy relics. The ideal state of nature was to be preserved for ever in death.

The Victorian love of nature was a kind of requiem. But it was not only this. The Industrial Revolution split the British affection for the natural world into two: drove a wedge

Joseph Paxton's lily house at Chatsworth House, Derbyshire. 1849.

right down the middle of it. On one side was this morbid sentimentality; but on the other was a passionate acquisitiveness.

Victorian painters are only passive witnesses to this acquisitive urge: they have left their dispassionate evidence in the wealth of scientific volumes they illustrated—on plants, birds, insects, geology, on the innumerable wonders of nature that caught the nineteenth-century imagination and zest for knowledge. That same irresistible human energy that powered industrial development, empire-building, banking, trade and exploration, fired the Victorians to collect every possible animal and bird for their zoos and every possible blossom and bush from the four corners of the earth for their gardens. No one, you might have thought, could have loved nature more.

As a result, not since the Romans had the English landscape been so transformed. Countless species of plants and trees that we take for granted in British gardens were actually introduced during this acquisitive century: jasmines, forsythia, many varieties of cedar and maple, rhododendrons from the Himalayas, lilac from just across the English Channel, from China the chrysanthemum, the camellia, peonies, azaleas. And from Brazil that hideous tree which the Victorians loved—the Monkey Puzzle. One of the most exotic of these imported plants took on—as it happens—what I can only describe as a visionary role in the advance of nineteenth-century industrial technology in this country. And in the two-faced relationship between industry and nature in that era, it possesses the status of a symbol.

This plant was the giant Amazonian water-lily. Of all the species of flora sent back by British explorers to the Royal Botanic Gardens at Kew, this was among the most strange

and dramatic. Stories of its vast size arrived first. These were followed by seeds and roots secured from the swamps of the Amazon basin. Attempts to grow them at Kew failed, to the chagrin of the royal gardeners.

But in 1849 a few seeds had also been acquired by the Duke of Devonshire at Chatsworth House in Derbyshire. The duke's head-gardener was Joseph Paxton, not a man to accept that Kew must know best. Paxton had already designed and constructed a number of glasshouses for his employer, including a gigantic conservatory with a roof sixty-seven feet high supported on cast-iron columns, and covering almost an acre of ground. Paxton, in fact, had more practical experience in growing tropical plants than any man alive. Besides, he was a genius: his imagination and ingenuity carried him far beyond the capabilities of mere experts. In short, he succeeded where the royal gardeners at Kew failed. He raised the giant water-lily from seed, and he brought it to flower. He promptly sent the first flower to Queen Victoria, who then graciously allowed the lily to bear her name: *Victoria regia.* Paxton was not one to miss a trick.

This was only the beginning. The lily grew so colossally that in November 1849 Paxton held the Victorian equivalent of a press conference at which he placed his seven-year-old daughter Annie on one of the leaves, dressed as a fairy, in order to demonstrate its strength. Sceptics claimed uncharitably that the leaf was supported from below: none the less Paxton's showmanship won him further publicity. Furthermore, he persuaded the duke to let him con-struct a special lily house more appropriate to the scale of the monster.

The new lily house at Chatsworth—sadly no longer in existence—looks modest enough from old photographs and engravings. But it possessed a 'ridge and furrow' roof, which Paxton had patented: what is more, parts of the glasshouse were *pre*-fabricated—which was revolutionary.

The year was 1850. A competition had been announced for the design of a vast building to house the forthcoming Great Exhibition of All Nations, to be held in London the following May. Paxton was a gardener, and a self-taught engineer, but he was not an architect, and it does not seem to have occurred to him to enter for such a high-sounding competition. Then, at the last minute he was persuaded to do so: the closing date was even extended to make it possible. Paxton sketched out a rough design on a piece of blotting-paper, and just nine days later he submitted the completed plans.

In what was one of the most imaginative decisions of the century, the judges awarded the commission to the Duke of Devonshire's head-gardener. So, the nation which had brought about the Industrial Revolution built a huge glass cathedral, which the magazine *Punch* dubbed the Crystal Palace, to show off its products to the envious eyes of the world (Plates 52 and 53). And the inspiration of that great showcase of industry was, as Paxton made clear, nature. 'Nature', he wrote, 'was the engineer—nature has provided the leaf with horizontal and transverse girders and supports that I, borrowing from it, have adopted in this building.'

The final clue to the design of the Crystal Palace had been given to Paxton by the giant water-lily which he had been the very first to grow. He had examined the structure, visible only on the underside, of its enormous leaves, and he had perceived how a fragile skin might

be supported by a web of slender membranes. If a leaf, why not glass? As Henry Cole, Prince Albert's right-hand man and chief organizer of the Great Exhibition, exclaimed, 'The history of the world, I venture to say, records no event comparable in its promotion of human industry. . . .'

The irony remains for us to savour as we look back at the high noon of British commercial optimism from its sunset. Here was the country that was pioneering the wholesale destruction of nature, and at the same time creating a gigantic shop-window whose very inspiration was . . . nature. Paxton's achievement lives in the mind as a token of that nineteenth-century ambivalence towards the natural world which pervades so much of that era—its writings, its art, its buildings, its way of life, its ethos. Wreckage of nature, and reverence for nature; devastation hand in hand with conservation. It is this irreconcilable contradiction of attitudes which is our heritage.

Joseph Paxton's blotting-paper sketch for the design of Crystal Palace, made on 11 June 1850.

NATURE AND
NOSTALGIA

he Industrial Revolution sowed an incurable anguish in the minds of those accustomed to thinking of England as beautiful. It had been easy for poets, painters and novelists to see pre-industrial England as Arcadia: villages fitted quite naturally into the countryside; towns by and large were compact and small; even the hovels of the poor could be perceived as quaint and picturesque. But no longer was this so. There was nothing remotely Arcadian about the Black Country. Wigan and Wolverhampton did not fit into the countryside so much as smother it. By the mid-nineteenth century painters had given up making factories and mills look romantic, and Elizabeth Gaskell was writing of her heroine's first view of Manchester as 'a deep lead-coloured cloud hanging over the horizon', bringing with it 'a faint taste and smell of smoke' (*North and South*). Progress, as the nineteenth century understood it, had become inimical to the vision of England as a green and pleasant land. Progress was creating a black and unpleasant land.

The Victorians reacted to this tragic anomaly with the contradictory attitudes I outlined in the previous chapter: they continued to plunder nature in the interests of science, progress and money; and they demonstrated their affection for it by stuffing their houses and gardens with nature, and decorating their industrial products with loving images of it.

How these contradictory attitudes came to be resolved was by swamping the whole subject of nature in nostalgia. Here was a sentiment which allowed Victorian poets and painters to gush over the beauty of the landscape, but to do so in a spirit of sweet lamentation for what was fading before their eyes. The advantage of nostalgia is always to be able to have it both ways.

The first strong whiff of it hangs over English painting from as early as the mid-nineteenth century. In the later landscapes of Samuel Palmer the visionary intensity has been replaced by wistfulness, a gentle Arcadian sob for a faraway land that was once England. But it is the Pre-Raphaelites and their associates who catch the spirit of it most richly. At the very height of the Industrial Revolution they were painting England more bright and beautiful than she had ever looked before.

They were not primarily landscape painters, but in much of their work the landscape is strongly present. All the smoke and steam that Turner loved have been swept away. What the Pre-Raphaelites felt to be the real England was timeless. And they recorded it facet by facet, with a reverence for detail which showed that they had listened to the exhortation of the critic John Ruskin to 'go to Nature . . . rejecting nothing, selecting nothing, and scorning nothing. . . .'

When he came to paint his Christian morality picture *The Hireling Shepherd* (Plate 55), William Holman Hunt left the two central figures to the last while he spent painstaking months getting the sheep and the landscape absolutely right, flower by flower. The same obsession with natural detail pervades Hunt's other famous 'sheep' picture, *Our English Coasts*, in which the strayed sheep are supposed to represent the disorganized military volunteers safeguarding England from invasion by Napoleon III—a kind of woolly Dad's Army. But the allusion must have been feeble even then, and the painting is in essence a paean of love for England's wild garden bathed in the radiance of evening light.

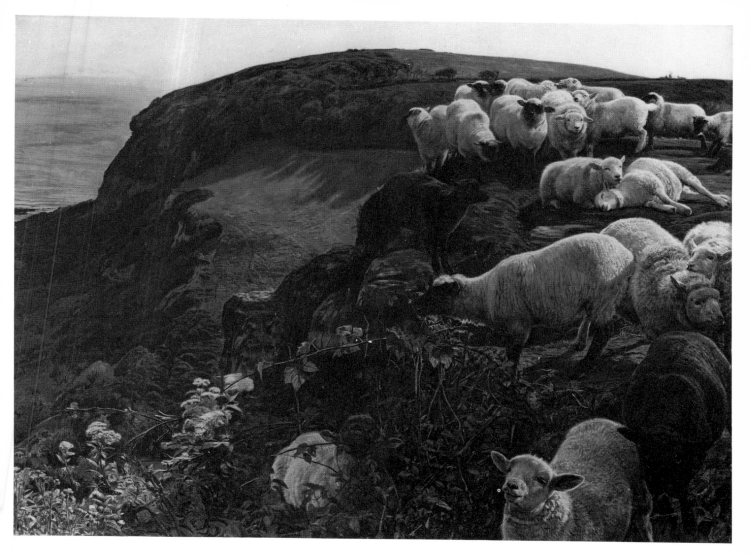

The note of nostalgia is even stronger in the paintings of John Everest Millais because of his fondness for employing landscape as a dramatic accompaniment to studies of pretty girls doing appealing things like building a bonfire (*Autumn Leaves*; Plate 54) or playing a concertina to a younger sister (*The Blind Girl*). Sunsets, rainbows, golden meadows, laden orchards, the burnished colours of autumn: these are nature's counterpoint to the sweet-sadness of Millais's human world. And, like Holman Hunt's, it is a bucolic world tinged with romantic melancholy.

William Homan Hunt, *Our English Coasts*. Oil. 1852. London, Tate Gallery.

The one artist of this group who did paint landscapes just as landscapes was Ford Madox Brown, never an actual member of the Pre-Raphaelite Brotherhood but always a close associate. It is one of the sadnesses of nineteenth-century English painting that Madox Brown did not concentrate more on landscapes than on biblical confections, because with the Bible out of his mind he painted the most radiant accounts of the countryside of the whole Victorian era (Plate 57).

They encase a nostalgic vision of rural England like cameos—sometimes, being oval in shape, they even suggest cameos. Lovers sit by a dovecot in the autumn sunshine, while before them spreads a bright carpet of English countryside broken only by a church spire, a

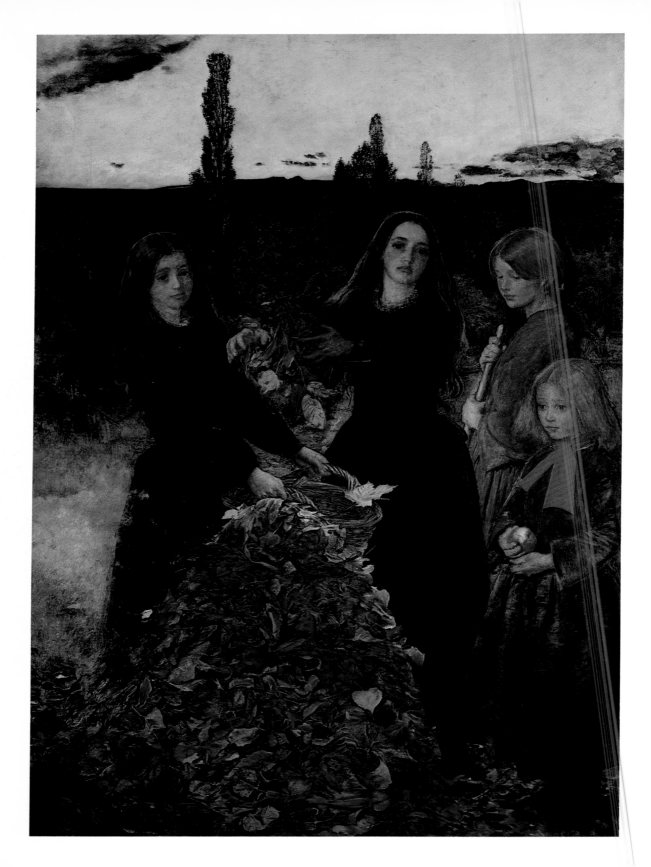

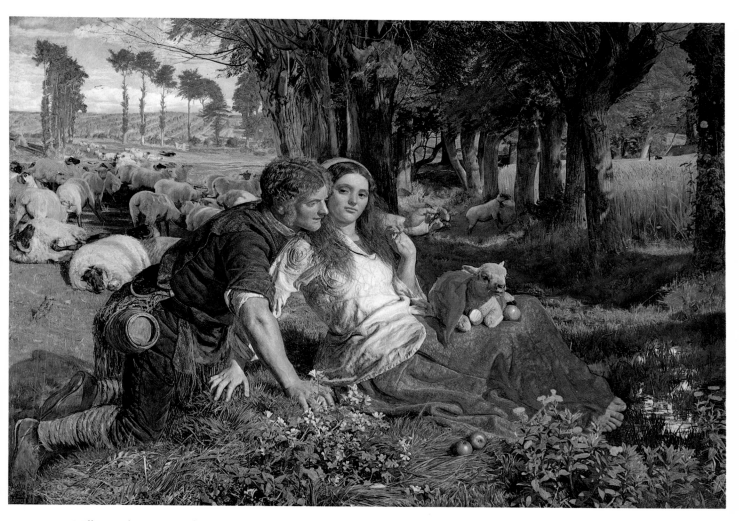

55 William Holman Hunt, *The Hireling Shepherd*. Oil. 1851. Manchester, City Art Gallery.

OPPOSITE 54 John Everett Millais, *Autumn Leaves*. Oil. 1856. Manchester, City Art Gallery.

village, a stately mansion. Or, a corn harvest is reaped under a golden evening light watched over by the ghost of a moon. In a similar picture the same moon, brighter now in the gathering dusk, presides over a party of hay-harvesters and invests the scene with a Samuel Palmer-like glow. Or, a rainbow loops over a flooded estuary with a windmill and a schooner under full sail, while another pair of lovers—probably the artist himself and his wife—gesture in delight at the scene before them, inviting us to do the same.

This is rich and glorious stuff. And it is the richer because it feels like a final celebration of a particular kind of relationship with nature which artists had enjoyed and expressed on canvas for the past hundred years: a relationship in which the countryside was taken for granted as the natural environment because England was by and large a rural nation.

The Pre-Raphaelites give us a view of England as a kind of smokeless zone. Precisely because industry was changing the world around them with such alarming speed, they present us with this pure and sometimes tearful vision of an England that does not and cannot change: an England rooted in the past—in nature, in history, in legend. It is a daydream of Olde England: remember! . . . remember! . . . Pre-Raphaelite paintings gather the past into our hearts and guard it there.

The anguish of the nineteenth century was fuelled by a myth which English landscape painters had to a great extent been responsible for cultivating. This was the myth that rural England was an idyll, a jewel of nature, a paradise on earth; and that the march of industry represented a hideous threat to it. In other words, we were fouling our own Garden of Eden.

True or not, here was a myth born of privilege and sentimentality—a view from the mansion, or a view from the easel. It would never have been supported by anyone who actually worked the land. Constable's labourers would certainly not have seen it that way, nor would Gainsborough's peasants at their cottage doors, nor Palmer's villagers of Shoreham making their way to church under the harvest moon.

With the break-up of the Pre-Raphaelite Brotherhood this view of England, and the mood of nostalgia which accompanied it, came to an end as a major force in English landscape art. It is true that between the late nineteenth century and the present day there has been a vast quantity of nostalgic landscape painting which still upholds this myth. Royal Academy Summer Exhibitions would look bare without it. But it is secondary art. Nostalgia had become a mark of the second-rate. The primary figures in modern landscape painting have invariably looked for other things.

A clear case is Stanley Spencer. Born in 1891 in the Berkshire village of Cookham-on-Thames, he remained tied all his life to the place of his birth, apart from bouts of study and war service. Spencer's Cookham was Constable's East Bergholt. It was the place he belonged to, full of ordinary things deeply felt: the fields, the gardens, the seasons, the gentle vistas (Plate 56). Spencer's landscapes look as though he had set out to illustrate Constable's vow that his art could be found under every hedge and in every lane. Like Constable, he loved nature for what it was, in its infinite variety of smallness. After the high dramas of Romanticism, and the anguish

Ford Madox Brown,
*An English Autumn
Afternoon*. Oil. 1852–4.
Birmingham, City
Art Gallery.

of artists trying to pretend the Industrial Revolution had never happened, this seems like a return to a perception of nature as the natural environment of man, as though nothing had really changed.

In fact, Spencer knew perfectly well the world *had* changed. Recluse though he was, religious mystic though he was, Spencer knew that most people did not live in rustic retreats like Cookham Vale, but in teeming cities like Glasgow, where he undertook a series of huge paintings of the ship-building industry. And he knew about wars, violence, pain: he had served in the medical corps in Macedonia during the First World War, and left a vivid account of his experiences in the little chapel he decorated at Burghclere in the 1920s.

It is because there was not an ounce of sentimentality or nostalgia in his view of the world that Spencer could turn to the countryside and paint it entirely objectively. The pleasure of Spencer's landscapes are pleasures of the eye, lovingly, carefully recording what lay before him, detail by detail, flower by flower. His sentiments were evoked by things as they are. Instead of recording rural England with a lump in the throat for the beautiful far-off days, Spencer looked at his own little patch of countryside and said, in effect, 'This will do.'

Between the two world wars a very different response to the natural environment emerged in and around the fishing-port of St Ives, in Cornwall. St Ives had been attracting visiting painters since the latter part of the nineteenth century. Whistler and the young Sickert spent some of the winter of 1884 there; and gradually a large number of artists succumbed to the charm of the place and to the impact of the Cornish landscape around. In addition to its pictorial appeal, St Ives was far away at the end of England and answered a need felt by so many artists of this period—escape from the tentacles of the metropolis.

But in the 1920s St Ives became more than just a place to visit and paint: it became a spirit. Ben Nicholson has left us this account of a trip he made with a fellow-painter Christopher Wood. (It first appeared in the magazine *Horizon* during the Second World War.)

56 Stanley Spencer, *Cottages at Burghclere*. Oil. 1930–1. Cambridge, Fitzwilliam Museum.

57 Ford Madox Brown, *The Hayfield*. Oil. 1855–6. London, Tate Gallery.

Ben Nicholson, *March 1948 (Tree, Lelant)*. Pencil. Private Collection.

In August 1928 I went over for the day to St Ives with Kit Wood: this was an exciting day, for not only was it the first time I saw St Ives, but on the way back from Porthmeor Beach we passed an open door in Back Road West and through it saw some paintings of ships and houses on odd pieces of paper and cardboard nailed up all over the wall, with particularly large nails through the smallest ones. We knocked on the door and inside found Wallis, and the paintings we got from him then were the first he made.

Alfred Wallis was a semi-literate retired fisherman and rag-and-bone merchant who had begun to paint at seventy for something to do. And it took him over. He did almost nothing else until his death in a workhouse above Penzance seventeen years later. He painted what his memory told him as though he were actually taking a walk round it. This was also how he worked, walking round the flat table he painted on and adding details from different angles. He would take whatever scrap of old shoe-box or cardboard carton he could get hold of, and bend his subject to fit it—rather as St Ives itself is bent round the shape of the shore-line.

Nicholson found in this uneducated man an instinctive and direct response to the outside world which academic art had all but lost. Wallis allowed his experience of a place, or an event, to dictate the form of a painting. His pictures conveyed the *feel* of ships, of being at sea, of the rocks and landscape, not simply the spectacle of things (Plate 58).

The discovery of Wallis seems to have confirmed in Nicholson's mind the rightness of his own approach to landscape painting, which invariably gave the same priority to immediate experience, with everything pared down, reduced to a few lines, shapes and colours, and images often rearranged so that they seem to be floating in the mind (Plate 59).

Ben Nicholson, *St Ives*.
Oil. 1940. Reddihough
Collection.

The paintings of Wallis and the early landscapes of Ben Nicholson reveal a fresh relationship between the artist and the natural world. It was no longer a matter of imposing on landscape a vision of something idyllic, or romantic, dramatic, or pretty—as eighteenth- and nineteenth-century English artists had done. And it had none of the faithful objectivity with which Stanley Spencer expressed his bond with the landscape around his beloved Cookham. Here was a relationship which grew out of instinctive responses. The artist awakened those responses by digging inside himself and asking the question 'What does it *feel* like to be here?' I experience, therefore I am.

Yet another response to the natural environment was aroused in English painters between the wars largely through the impact of Surrealism. The continental Surrealists (in particular Ernst, Masson and Miró) propounded a liberation of the unconscious from the tyranny of reason: the source of 'true' experience and therefore of true creativity was the dream. The guru of the Surrealists was naturally Sigmund Freud, a role he disclaimed with some contempt for their products.

But where the continental Surrealists tended to concentrate on themes that centred on people, characteristically most of their English counterparts turned to the inspiration of landscape: or, more accurately, Surrealism touched the imagination of English artists who were already landscape painters. Surrealism offered a revitalized way of experiencing the natural environment.

Another difference was that English Surrealists—or painters who felt the pull of Surrealism—were able to attach it to an undercurrent of English mystical painting which like-wise had its source in dreams. This was the tradition of William Blake, and in particular the

58 Alfred Wallis, *St Michael's Mount with Yellow Sailing Boats*. Oil. *c*.1930. Cambridge, Kettle's Yard Collection.

59 Ben Nicholson, *Tendrine 2 (Cornwall)*. Oil. 1947. Washington, DC, The Phillips Collection.

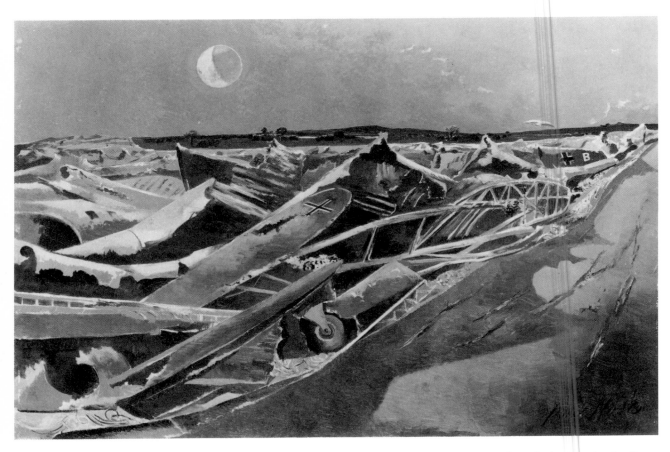

Paul Nash, *Totes Meer*.
Oil. 1940–1. London,
Tate Gallery.

Blake whose dream landscapes had illustrated Dante's *Divine Comedy* and Thornton's *Virgil*.

Paul Nash is the most interesting of these mystical landscape painters: his experience of nature is richer than others and more varied, and his work endures where that of many of his contemporaries now seems affected and whimsical. His search for an emotional contact with landscape drew him to the landmarks of prehistoric Britain. The mysteries shrouding the ancient megaliths were like keys to a lost language. Nash was particularly attracted to the stone circles of Avebury, which he discovered while he was staying at Marlborough in the summer of 1933. The following year, in the art publication *Unit One*, he wrote this account.

Last summer, I walked in a field near Avebury where two rough monoliths stand up, sixteen feet high, miraculously patterned with black and orange lichen, remnants of the avenue of stones which led to the Great Circle. A mile away, a green pyramid cast a gigantic shadow. In

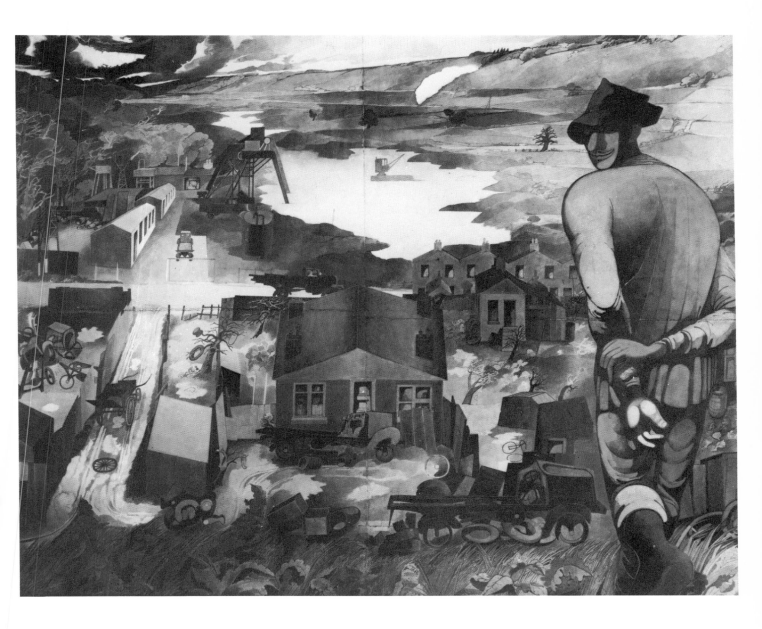

Edward Burra, *Rye Landscape with Figure*. Watercolour. 1947. Bedford, Cecil Higgins Art Gallery.

the hedge, at hand, the white trumpet of a convolvulus turns from its spiral stem, following the sun. In my art I would solve such an equation.

In some unpublished notes which Nash prepared for his London dealer some ten years later, the artist explained how at first the pictures that came out of this preoccupation were concerned with ancient stones solely as objects seen in relation to landscape, but that later the stones took on a character influenced by dream.

So, relationship with landscape becomes a revelation of mystical truths. The creative process unlocks the gates to a lost world where nature and man were presumed to be joined in some kind of spiritual harmony. Nash was forever searching for the magic that he felt lay out of reach of reason: nature was full of messages and strange correspondences which an artist could notice but not decode.

Here was a vision of England as a magic place, with the artist himself as visionary— Prospero with a paintbrush for a magic staff. It was typical of Nash—typical of an English painter—that he entitled the picture most strongly indebted to continental Surrealism *Landscape from a Dream* (Plate 60). It had to be a landscape, a real English coastline, for the dream to have a proper home. And it was just as typical of Nash that, as an official war artist in the Second World War, he should have transformed a field of wrecked German aircraft into a sea of strange monsters lying dead under the eye of the moon and the eye of a predatory owl.

A generation of British artists shared this visionary perception of nature in the first half of the twentieth century: Graham Sutherland's great heaving hills that are awesome and menacing, forever suggesting some inner spirit none too well disposed towards mankind; Edward Burra's eerie panoramas, striking in colour with a faintly diseased air (Plate 61); Ceri Richards' interpretations of music in terms of landscape and natural images, such as Debussy's *The Cathedral under the Sea*; John Piper's black Welsh hills and valleys shafted with light and shadow; Ivon Hitchens' secret woodlands in autumn lit by a blaze of bracken (Plate 62).

This was the romantic era in twentieth-century English landscape painting, and it flourished most strongly in the isolation of the war years when painters were thrown back on native traditions—that of Blake and Palmer in particular. Perhaps isolation was not sustained quite long enough: what might have been a confident last flowering of landscape painting blossomed only fitfully in the post-war years under the arc-lights of international styles and movements from the Continent and later from the United States.

Today there are certainly just as many painters of landscape, and painters of nature generally, as there ever were. But they no longer seem to stand in the vanguard. It may be that a relationship to nature, which so much English painting has been a search for—or an expression of—over the past two hundred and fifty years, is nowadays taken for granted and offers little new stimulus or food for thought. Communications are so easy, Snowdon is being worn away by hikers, and you have to go an awful long way to find landscape that excites anew.

Even then, paint and brushes are no longer the obvious means of capturing the impact of such places. Artists more than ever have turned to photography. In the late nineteenth

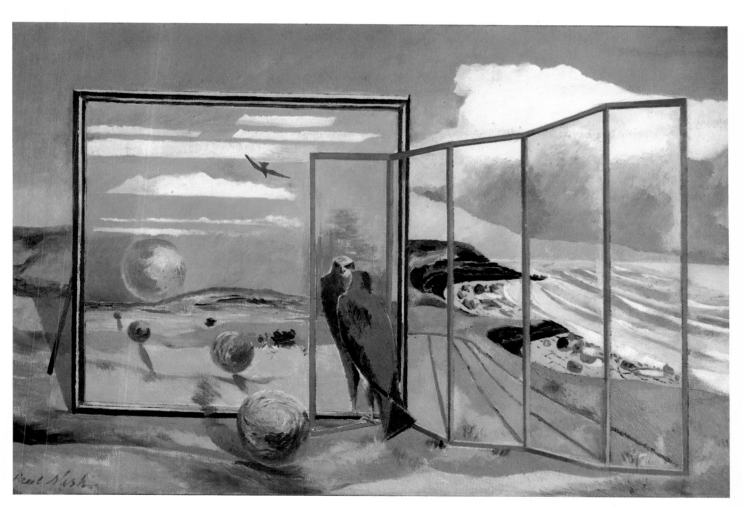

60 Paul Nash, *Landscape from a Dream*. Oil. 1936–8. London, Tate Gallery.

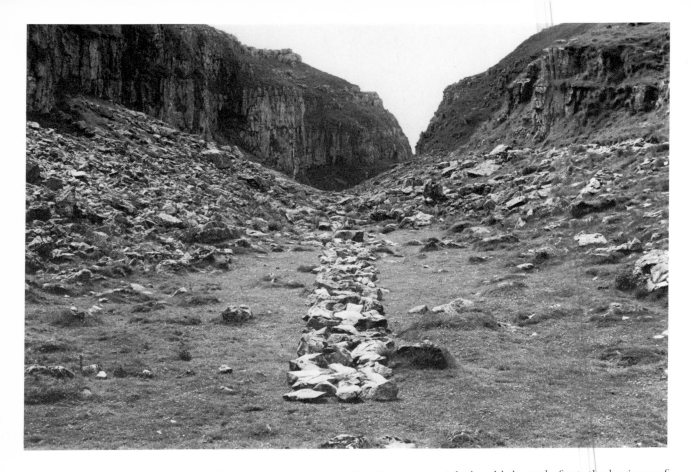

Richard Long, *A Line in England*. Yorkshire, 1977.

century, when it was first thought that the camera might herald the end of art, the business of photography was so cumbersome and imprecise as to be no real threat at all. Today, polaroids, instamatics, lightweight cine and video cameras, have changed all that: they have affected our responses to the natural world just as television has changed our perception of it. For many artists, and for a vastly greater number of people who are not artists, the photographic image has become more than an aid to memory: it is the way the world is actually perceived, and the medium through which experience of the world is most naturally conveyed.

It is no surprise, then, that several leading British artists of the 1970s and 1980s should have explored their relationship to landscape through the camera. Richard Long is the most successful of these. Long is a sculptor and a photographer. What he photographs are his travels, and the marks of his travels: a line where he has walked, a pattern of stones he has made on a beach or hilltop, pieces of wood arranged in a circle, and other signs that the artist has been there, and departed. His photographs are a record, indeed the only record that can be shared, except when he traces his journeys on a map or arranges objects brought from the landscape as an exhibit in an art gallery.

Long's work strikes me as a personal and elegant way of expressing a very physical response to landscape—the same response enjoyed by thousands of people who do not think of themselves as artists, when they tramp the Ridgway and the Pennine Way every summer in the solitude of nature. I experience, therefore I am.

But where did the nostalgia go? Nowhere in all these twentieth-century visions of England is

there that lump in the throat which characterizes so much Victorian art. There are no tearful celebrations of a paradise about to be lost. Yet the culture of nostalgia thrown up by the Industrial Revolution has not just ebbed away. What has happened, it seems to me, is that it has filtered through into the actual environment of our life. It is nostalgia which has been responsible for one of the great British inventions—the green city.

Only the nation that created the Industrial Revolution could conceivably have created the green city. Before the Industrial Revolution greenness could be taken for granted. Nature was out there all around, unspoilt and unthreatened, and if you wanted to go and live in it you could. But if you chose the city then you lived in a city house: there was no point pretending you lived among nature since real nature was only a mile or so away.

Industry changed all this. It began to spoil nature, and it filled the cities with dirt. So a new British ideal had to be invented: the suburban nature reserve. The first green suburb was Norman Shaw's Bedford Park, built in west London during the 1870s; and others followed in ever-increasing profusion from the 1880s and on through the present century. Architectural styles have varied, though not very much, but the ideal has remained precisely the same. The suburban nature reserve offers people who work in an industrial milieu a home in an environment which looks as if the Industrial Revolution had never happened.

Of the architects who followed Norman Shaw a few are remembered: Voysey, Lethaby, Mackmurdo, Baillie Scott, Newton, Prior. Not many more. Mostly they remain anonymous. And yet these scores of unknown or little-known architects are the Michelangelos of the age of nostalgia no less than the great nineteenth-century engineers were the Michelangelos of

Richard Long,
Connemara Sculpture.
1971.

61 Edward Burra, *Near Whitby, Yorkshire*. Watercolour. 1972. By courtesy of the Lefevre Gallery, London.

62 Ivon Hitchens, *Woodland, Vertical and Horizontal*. Oil. 1958. London, Tate Gallery.

the age of industry. It has been their nose for nostalgia which has given us the Queen Anne style, neo-Palladianism, neo-Georgianism, neo-Dutch, neo-just-about-everything-else, and—above all—that triumphant symbol of the suburban Paradise Regained, Stockbrokers' Tudor.

The ethic of Paradise Regained is that anything which suggests pre-industrial life, and anything to do with the countryside, means quality. It is oak-beams and carriage lanterns. It is antique shops and garden centres, rustic seats and take-away ponds, bottle-glass windows and thatched tit-boxes. It is advertisements for lager swigged by mountain torrents. It is beer from the wood delivered by teams of shire-horses to High Street pubs built to look like medieval coaching-inns.

This is where nostalgia has gone. And it has spilled into the countryside itself. Nature itself has become a conservation area, with zoos, safari parks, National Trust territories. Farm-buildings that were once routine and functional are transported lovingly to open-air museums of rural life. 'Typical' has come to mean 'There is only one left and here it is.' Traditional rural crafts are kept going, or revived, by government sponsorship because they are felt to represent a lifeline to a pre-industrial era which we cannot afford to break. Altogether, it is as if we have come to feel more spiritually at ease with the past than with the present.

Even the very birthplace of the Industrial Revolution—Coalbrookdale in the Severn Valley—has become absorbed into Paradise Regained. Here was where Abraham Darby became the first man to succeed in smelting iron with coke rather than charcoal; and where Darby's grandson created one of the new wonders of the world, when he threw the first-ever Iron Bridge across the gorge of the Severn in 1779. Here English eighteenth-century artists in search of the picturesque took out their sketch-books and recorded the furnaces which were soon to set a blaze across the Black Country.

Today the industrial holocaust has passed on. Coalbrookdale is abandoned. So, what have we done? What we love to do most: made it into a garden, returned it all to nature. It is another open-air museum, and all those bits of industrial hardware have become picturesque monuments once again, looking romantic among wild flowers.

Only a few miles up-river stands the relic of another holocaust: the Cistercian abbey of Buildwas in Shropshire, wrecked by Henry VIII during the Dissolution of the Monasteries. This, too, has been lovingly returned to nature. A garden of industry. A garden of religion. Well-manicured lawns fringe the trunks of battered stone, and thanks to transport (which industry supplies) we can come here on a glorious summer evening and bathe in the sweet and sour nostalgia of it all.

In the age of nostalgia the real change would seem to be, quite simply, that nature can no longer be taken for granted as for so many centuries it was. There is widespread consciousness that it could disappear unless we look out. Nature, in fact, is no longer the natural state: it is the preserved state. What we love has become an endangered species.

OPPOSITE
The Coalport Museum, Ironbridge.

FURTHER READING

BOASE, T. S. R. (ed.), *The Oxford History of English Art* (planned in eleven volumes, to 1940), Oxford

BONY, J., *The English Decorated Style*, Oxford, 1979

BROOKS, J., *The Arthur Negus Guide to British Glass*, Feltham, 1981

CLARK, K., *The Gothic Revival*, London, 1928 (revised 1962)

CLIFFORD, D., *A History of Garden Design*, London, 1962

CLIFTON-TAYLOR, A., *The Cathedrals of England*, London, 1967

CLIFTON-TAYLOR, A. (and others), *Spirit of the Age*, London, 1975

GAUNT, W., *A Concise History of English Painting*, London, 1964

GIROUARD, M., *Sweetness and Light: the 'Queen Anne' Movement, 1860–1900*, London, 1977

HELLYER, A., *The Shell Guide to Gardens*, London, 1977

KLINGENDER, F., *Art and the Industrial Revolution*, London, 1968

MULLINS, E., *The Arts of Britain*, Oxford, 1983

MULLINS, E., *The Painted Witch*, London, 1985

PEVSNER, N., *The Englishness of English Art*, Harmondsworth, 1964

PIPER, D., *The Genius of British Painting*, London, 1975

RICHARDS, J. M., *The National Trust Book of English Architecture*, London, 1981

STRONG, R., *The English Icon*, London, 1969

WATERHOUSE, E., *Painting in Britain, 1530–1790*, Harmondsworth, 1953

WILSON, S., *British Art from Holbein to the Present Day*, London, 1970

ACKNOWLEDGEMENTS

The author and publishers would like to thank all those who have given permission for works in their collections to be reproduced or who have provided photographs for use in this book. (Bold type indicates Plate numbers; other references are to page numbers.)

© ADAGP 1985, **26**, 64; By courtesy of Birmingham Museums and Art Gallery, **1**, 141; Reproduced by courtesy of the Trustees of the British Library, **38**, 97 (left); Reproduced by courtesy of the Trustees of the British Museum, **15**, **16**, 12; Chatsworth House, Devonshire Collection, Reproduced by Permission of the Trustees of the Chatsworth Settlement, **11**, **12**, 36; Messrs. John Dewar & Sons Ltd., 56; Mary Evans Picture Library, 72; Jeanette Hayhurst, 76; Reproduced by kind permission of the Trustees of the Cecil Higgins Art Gallery, Bedford, 149; A. F. Kersting, 97 (right), 104; City of Manchester Art Galleries, **27**; Merseyside County Council, **3**; © Museum of London, **44**; By courtesy of the Trustees of the National Gallery, London, **2**; National Galleries of Scotland, Edinburgh, 64; By courtesy of the National Portrait Gallery, London, **34**; The National Trust, **13**, **14** (photo: Mike Williams), **17** (photo: Graham Challifour), **20**, 49; Pronuptia de Paris (on loan from Michael Braham), **35**; Harry Smith Horticultural Photographic Collection, **10**, **40**, **41**; Norman Summers (photo), by kind permission of Mrs N. Summers and with special thanks to the Provost of Southwell, 100; © *The Sunday Times* (photo: Lorna Cattel), **36**; Tate Gallery, **25**, **66**, **68** (left); Jeremy Whitaker, **19**; Windsor Castle, Royal Collection, Copyright reserved, Reproduced by Gracious Permission of Her Majesty the Queen, **34**; Woodmansterne, **40** (photo: Clive Friend), **41** (photo: Nicholas Servian), **42**, **43** (photos: Jeremy Marks). The quotation from T. S. Eliot, *Four Quartets* (p. 62) is reprinted by permission of Faber and Faber Ltd.

INDEX